ACQUISITION PRIORITIES: ASPECTS OF POSTWAR PAINTING IN EUROPE

ACQUISITION PRIORITIES

ASPECTS OF POSTWAR PAINTING IN EUROPE

This project is supported by a grant from the National Endowment
for the Arts in Washington, D.C., a Federal Agency

The Solomon R. Guggenheim Museum, New York

ISBN 0-89207-041-2

Library of Congress Catalog Card Number 83-060-337

Table of Contents

Lenders to the Exhibition

Julian J. Aberbach
Teresita Fontana, Milan
Richard Hamilton
Mr. and Mrs. Morton L. Janklow
Mrs. Jacob M. Kaplan, New York
The Kempe Collection
Susi Magnelli
Arnulf Rainer
Mrs. Hannelore B. Schulhof
Mr. and Mrs. Stephen Simon, New York
Jerry and Emily Spiegel
Mr. William H. Wise, Palm Springs, California

The Solomon R. Guggenheim Museum, New York

Acquavella Galleries Inc., New York
Thomas Ammann Fine Art, Zürich
Gallery Claude Bernard Inc.
Galerie Jeanne Bucher, Paris
Castelli Feigen Corcoran, New York
André Emmerich Gallery Inc., New York
Sidney Janis Gallery, New York
Lefebre Gallery, New York
Marlborough Gallery, New York
Sperone Westwater Fischer Inc., New York
Galerie Rudolf Zwirner, Cologne

Acknowledgements

This exhibition of modern European painting necessarily concerns many individuals who make up the creative art world in Europe today. Two-thirds of the twenty-seven artists represented here are alive, and many of these became involved in one way or another in the Guggenheim's preparations for the show. It is, therefore, to the artists themselves or to those who represent their legacies—executors, dealers or members of their families—that we are above all indebted.

The names of lenders, limited for the purpose of this exhibition to private collectors and dealers, are listed separately in this catalogue. Their contributions in every instance add significantly to the quality of the show and in some cases may come to enhance the richness of the Guggenheim collection. A number of postwar European works already in the Museum's collection have come to us through the generosity of our friends. The names of these donors, to whom we are greatly indebted, are listed in the captions of the illustrations in the present catalogue.

Energetic and informed efforts by Museum staff on all levels are always required to realize an exhibition of this scope and an accompanying catalogue. In this instance, staff members most centrally concerned with these tasks in addition to Lisa Dennison, Assistant Curator, include Diane Waldman, Deputy Director, and Carol Fuerstein, Editor. In addition, I wish to acknowledge the use in the present catalogue of a number of artist biographies derived from *Handbook: The Guggenheim Museum Collection*, the Handbook of the permanent collection by Vivian Endicott Barnett, the Guggenheim's Curator. I would like to express my sincerest thanks to all of these individuals for their invaluable assistance.

The financial demands of the present undertaking were met in part by a grant from the National Endowment for the Arts, which also funded the previous exhibition devoted to postwar painting in America. Our deepest gratitude is due to this agency for its continuing support of our programs.

THOMAS M. MESSER, DIRECTOR
The Solomon R. Guggenheim Foundation

Foreword

This exhibition is a sequel to *Acquisition Priorities: Aspects of Postwar Painting in America,* held at the Guggenheim Museum in 1976. Since the present show maintains all the attributes of the previous one, with the exception of the theater of activity and the protagonists involved, explanations, justifications and texts for the earlier exhibition may be repeated here in near identical form and sequence.

Like its precursor, then, the current exhibition is primarily a balance sheet—a frank admission of what, within a particular context, we value most and, conversely, what we at present most sorely lack. The selection consists of works from the Museum's permanent collection shown alongside others that are not part of its present holdings but are high on our list of acquisition priorities. The juxtaposition of assets and liabilities thus takes the form of an institutional self-critique, a public projection of our weakness rather than our strength. At the same time the exercise is meant to be remedial, for the borrowed works on view can, and to some extent perhaps will, be acquired either now or in the future. With the possibility of such acquisitions in mind, all loans were drawn from private collections or from commercial galleries. Works from the former source are, at least theoretically, potential donations; those from the latter source, potential purchases. However, while some paintings in the show are at present subjects of negotiation between their owners and the Guggenheim, others are included merely for their exemplary attributes and without real expectation of acquisition in the foreseeable future.

The presentation is not meant as a general survey of the period covered. Only incidentally and insofar as it expresses the Guggenheim's acquisition priorities does the exhibition provide a review of certain aspects of postwar painting in Europe. The selection spans the postwar years and covers a wide range in terms of generations. The oldest artist included was born in 1888, the youngest in 1937—a range extended only slightly beyond the one within which the American selection was confined.

The acquisition priorities reflected in this exhibition are our own, and we raise no claims for their validity beyond this Museum's needs as we assess them. I made the selection from the Guggenheim's collection and chose those works not now in our holdings with the help and the concurrence of the Museum's curators especially close to the subjects, in particular Diane Waldman, Deputy Director. Lisa Dennison, Assistant Curator at the Guggenheim, has taken an active part by leading the search for loans that might eventually become part of the collection.

This exhibition's American model has, within the seven years that have since elapsed, impelled an acquisition process that is far from negligible. *Acquisition Priorities: Aspects of Postwar Painting in America* included thirty-two painters. Works by nineteen of these were marked as priorities, and in eleven instances either the specific work requested or a comparable one has since come to enrich the Guggenheim's permanent collection. One can hardly hope for more in the exhibition's European counterpart.

Acquisition priorities of course remain a constant for any museum actively engaged in collecting. To the extent to which existing priorities are fulfilled by acquisition, new ones arise. Through such a process, our present narrow format may broaden into a less restrictive, richer and more comprehensive exhibition statement. The gradual and still continuing development of the Guggenheim's prewar collection—the result of a nearly fifty-year effort—will, we trust, point the way.

T.M.M.

Index to the Checklist

Works in the Exhibition

The checklist is arranged chronologically by artists' birthdates. Artists born in the same year are listed alphabetically and paintings are listed chronologically under each artist. Height precedes width. The acquisition number of each piece follows The Solomon R. Guggenheim Museum Collection credit line: the first two digits of this number indicate the year in which the work was acquired.

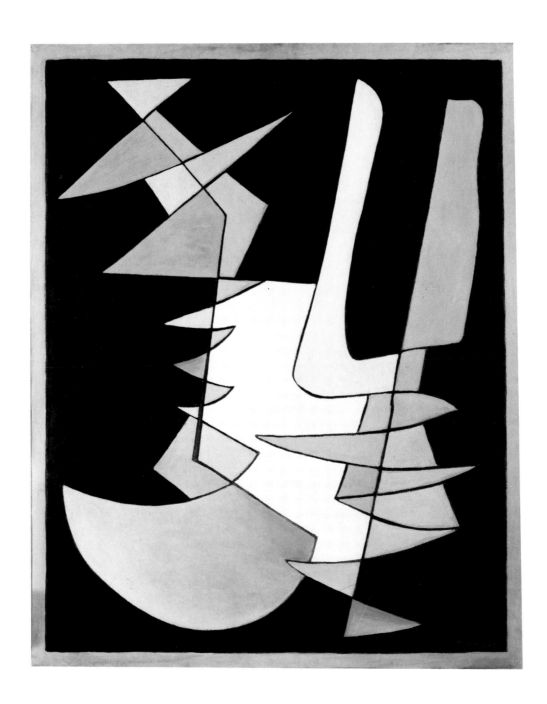

ALBERTO MAGNELLI 1888-1971

1 *Opposition No. 1.* 1945
 Oil on canvas, 39⅜ x 31⅞″ (100 x 81 cm.)
 Collection Susi Magnelli

ALBERTO MAGNELLI

2 *Formes réglées.* 1958
 Oil on canvas, 57½ x 38¼″ (146 x 97 cm.)
 Collection Susi Magnelli

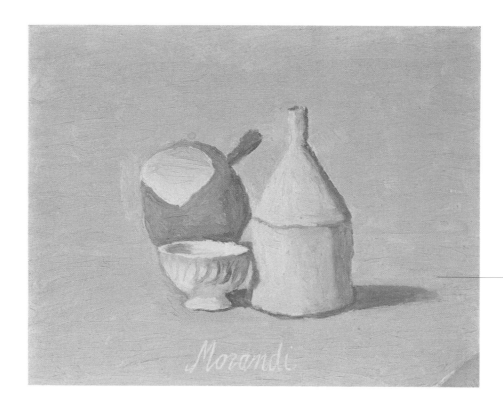

GIORGIO MORANDI 1890-1946

3a *Still Life.* 1948
Oil on canvas, 13¾ x 17¾″ (34.9 x 45.1 cm.)
Collection Mrs. Jacob M. Kaplan, New York

3b *Still Life.* ca. 1952
Oil on canvas, 13¾ x 19¼″ (34.9 x 48.9 cm.)
Collection Mrs. Jacob M. Kaplan, New York

JULIUS BISSIER 1893-1965

4 *Dark Whitsunday (Dunkler Pfingsttag).* May 21, 1961
 Egg-oil tempera on batiste, 17⅜ x 19″ (44.2 x 48.2 cm.)
 Collection The Solomon R. Guggenheim Museum, New York
 Gift, Mrs. Andrew P. Fuller, 1976
 76.2258

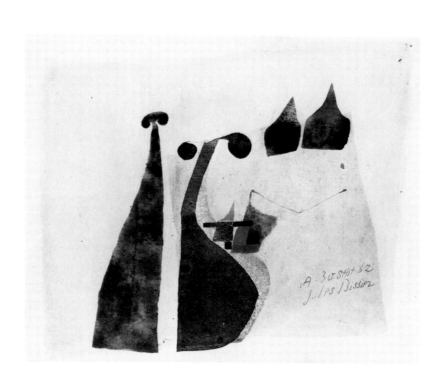

JULIUS BISSIER

5 *Untitled.* September 30, 1962
Tempera on canvas mounted on paper, 10 x 14⅜″ (25.4 x 36.5 cm.)
Collection The Solomon R. Guggenheim Museum, New York
Gift, Mrs. Lisbeth Bissier, 1982
82.2971

JULIUS BISSIER

6 *H. 16. 3. 64.* 1964
 Ink on paper, 19⅛ x 24¾″ (48.2 x 62.5 cm.)
 Gift in exchange, Mrs. Lisbeth Bissier, 1976
 76.2231

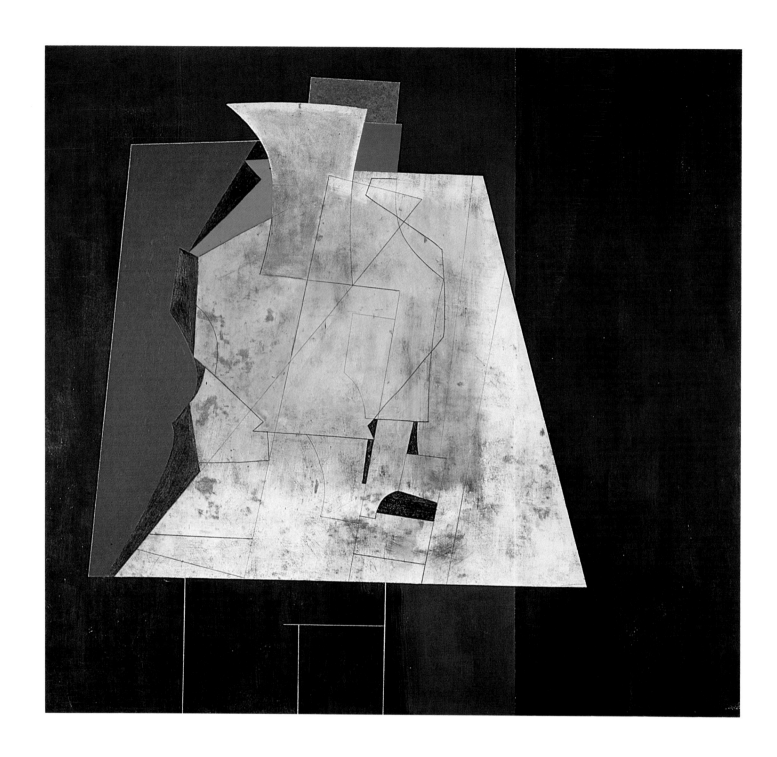

BEN NICHOLSON 1894-1982

7 *December 1955 (night façade).* 1955
Oil on board, 42½ x 45¾″ (108 x 116.2 cm.)
Collection The Solomon R. Guggenheim Museum, New York
57.1461

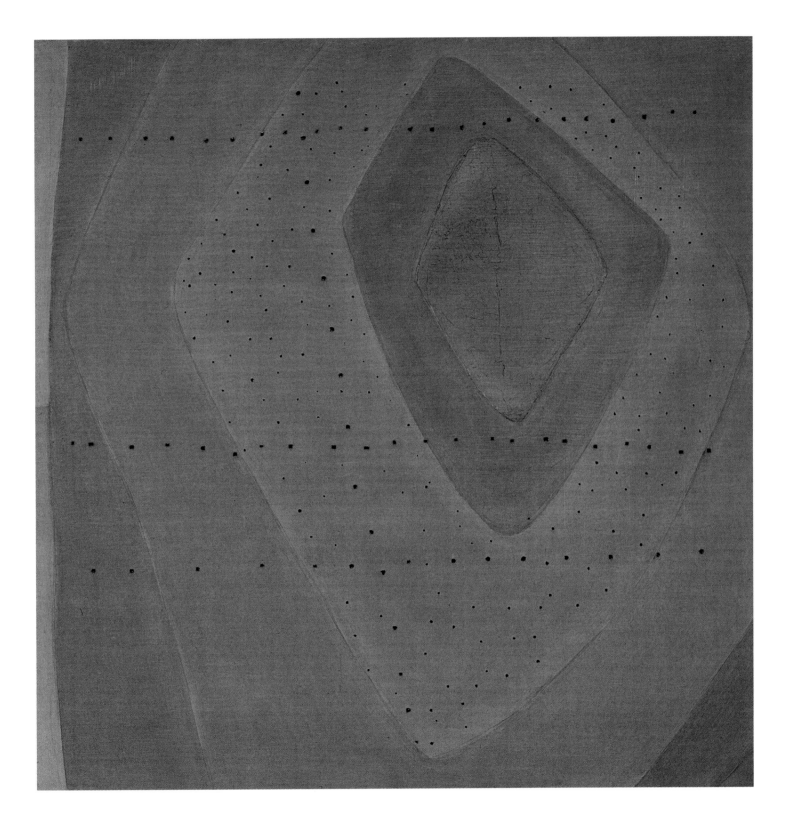

LUCIO FONTANA 1899-1968

8 *Spatial Conception 57 I 4 (Concetto Spaziale 57 I 4).* 1957
 Aniline and collage on canvas, 58⅝ x 59″ (149 x 150 cm.)
 Collection Mrs. Teresita Fontana, Milan

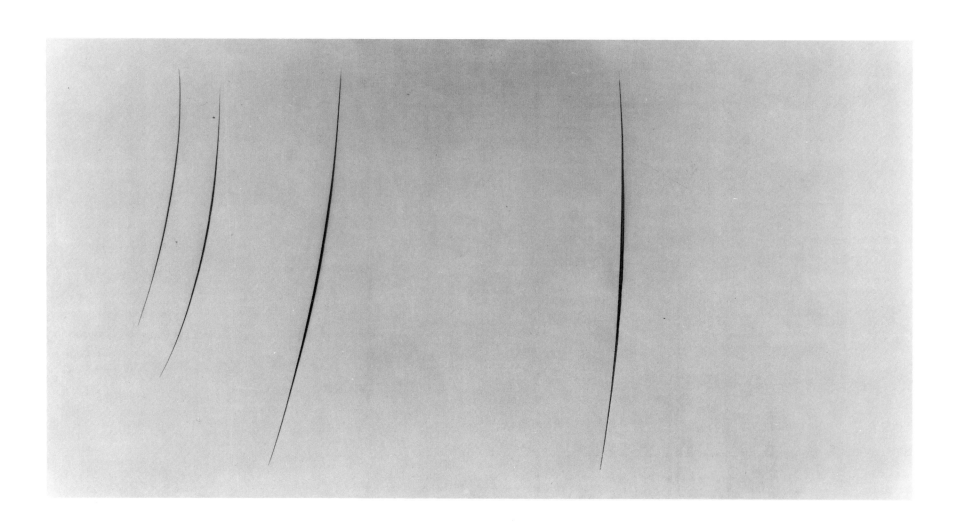

LUCIO FONTANA

9 *Spatial Conception, Expectations 59 T 133 (Concetto Spaziale,*
 Attese 59 T 133). 1959
 Water-based paint on canvas, 49⅝ x 98¾" (126 x 250.9 cm.)
 Collection The Solomon R. Guggenheim Museum, New York
 Gift, Mrs. Teresita Fontana, Milan, 1977
 77.2322

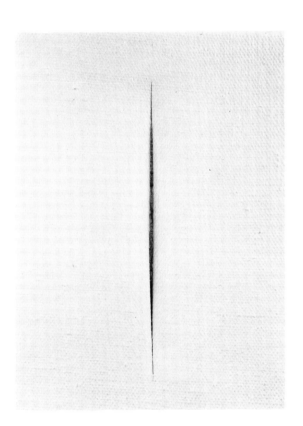

LUCIO FONTANA

10 *Mini-White.* 1966
 Oil on canvas, 8½ x 6″ (21.5 x 17 cm.)
 Collection Mrs. Hannelore B. Schulhof

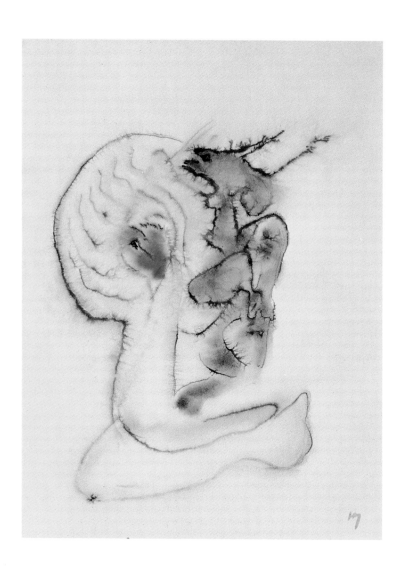

HENRI MICHAUX b. 1899

11 *Untitled.* 1948
Pencil and watercolor on paper, 15⅜ x 11½″ (39.1 x 29.2 cm.)
Collection The Solomon R. Guggenheim Museum, New York
65.1772

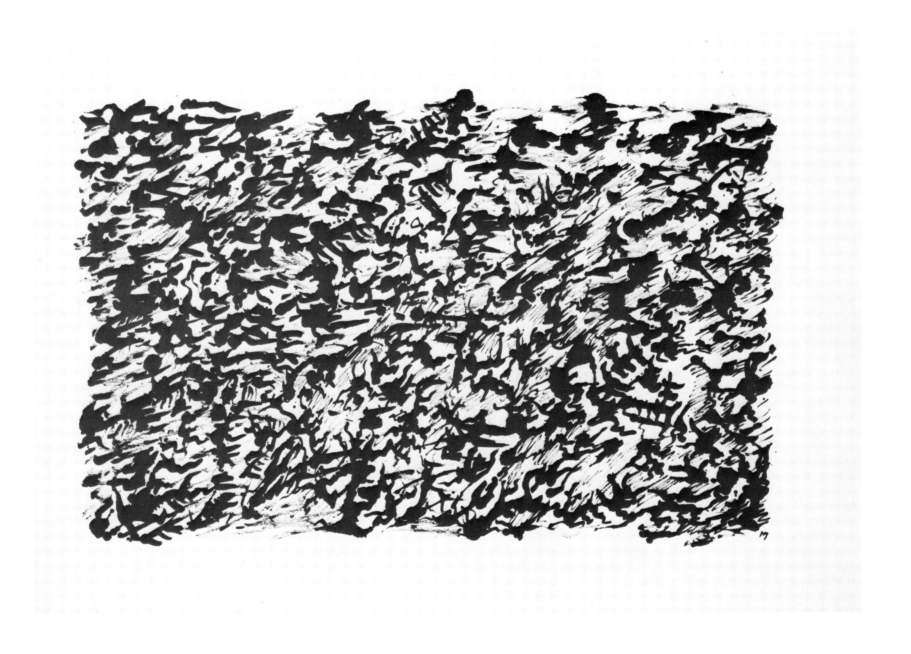

HENRI MICHAUX

12 *Untitled.* June 1960
India ink on paper, 29⅛ x 43¼" (74 x 109.9 cm.)
Collection The Solomon R. Guggenheim Museum, New York
Anonymous Gift, 1974
74.2082

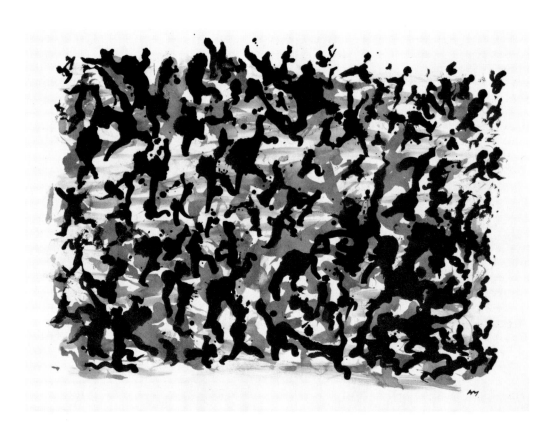

HENRI MICHAUX

13 *Untitled.* 1969
Ink on paper, 21½ x 29½″ (54.5 x 75 cm.)
Collection The Solomon R. Guggenheim Museum, New York
70.1929

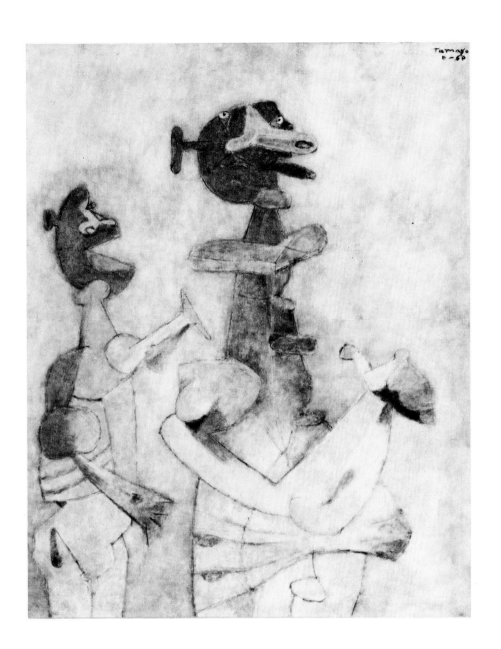

RUFINO TAMAYO b. 1899

14 *Man with Cigar (Hombre con puro).* 1950
Oil on canvas, 32⅛ x 25¾″ (81.5 x 65.5 cm.)
Collection Mr. and Mrs. Stephen Simon, New York

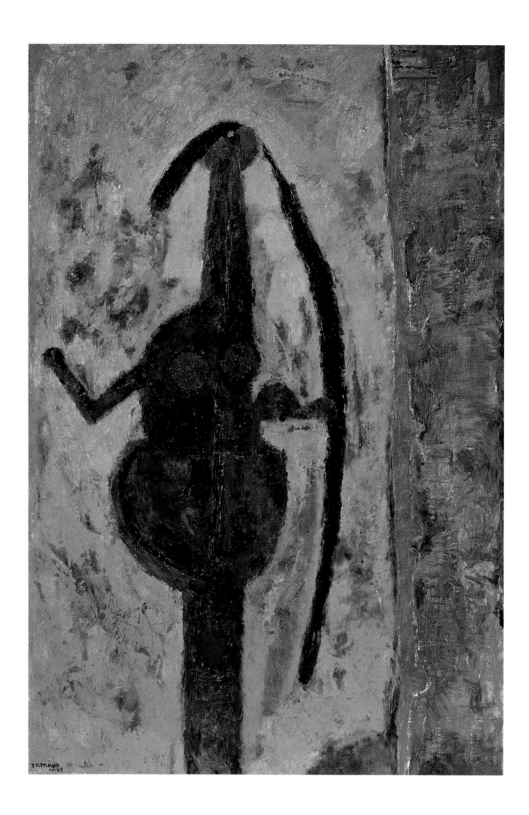

RUFINO TAMAYO

15 *Woman in Grey (Mujer en gris).* 1959
 Oil on canvas, 76¾ x 51″ (195 x 129.5 cm.)
 Collection The Solomon R. Guggenheim Museum, New York
 59.1563

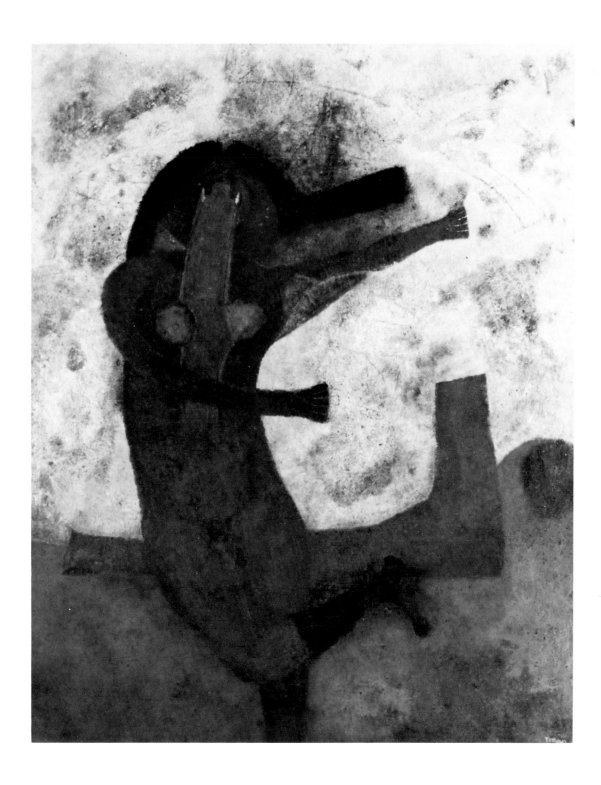

RUFINO TAMAYO

16 *Dancer (Danzante).* 1977
 Oil on canvas, 68½ x 54⅞″ (174 x 146.5 cm.)
 Collection The Solomon R. Guggenheim Museum, New York
 77.2398

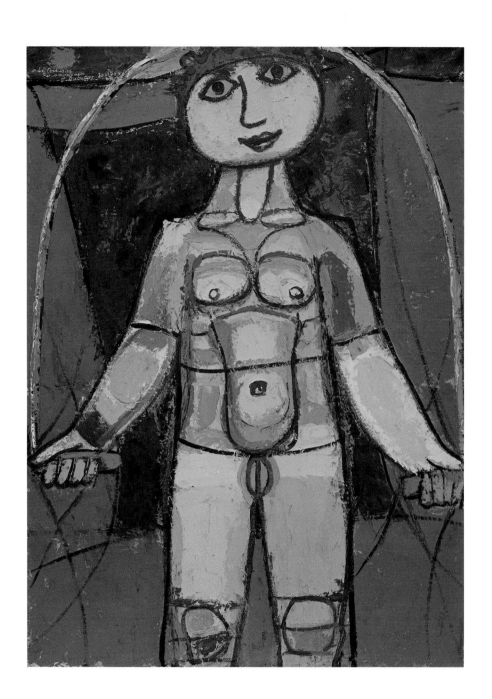

JEAN DUBUFFET b. 1901

17 *Rope Skipper (Danseuse de corde).* February 1943
Oil on canvas, 39⅛ x 28¾" (100 x 73 cm.)
Collection Mr. and Mrs. Morton L. Janklow

JEAN DUBUFFET

18 *Archetypes (Archétypes).* May 1945
Incised thick impasto and mixed media on canvas,
39⅛ x 31¾″ (99.3 x 80.9 cm.)
Collection The Solomon R. Guggenheim Museum, New York
74.2075

JEAN DUBUFFET

19 *The Substance of Stars (Substance d'astre).* December 1959
Metal foil on Masonite, 59 x 76¾" (150 x 195 cm.)
Collection The Solomon R. Guggenheim Museum, New York
74.2078

JEAN DUBUFFET

20 *Irish Jig (La Gigue irlandaise).* September 18-19, 1951
 Oil on canvas, 44⅞ x 57½″ (114 x 146 cm.)
 Collection The Solomon R. Guggenheim Museum, New York
 74.2079

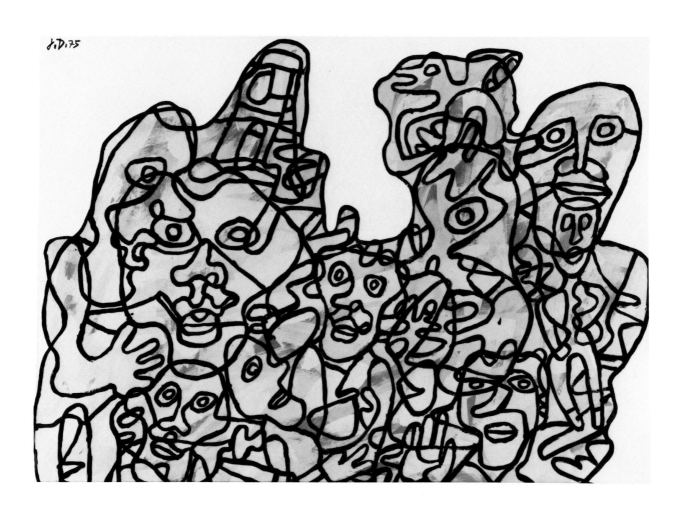

JEAN DUBUFFET

21 *Mundaneness IX (Mondanité IX).* March 4, 1975
 Vinyl on paper mounted on canvas, 25⁷/₁₆ x 36¼″ (165 x 92 cm.)
 Collection The Solomon R. Guggenheim Museum, New York
 Gift of the artist, 1981
 81.2835

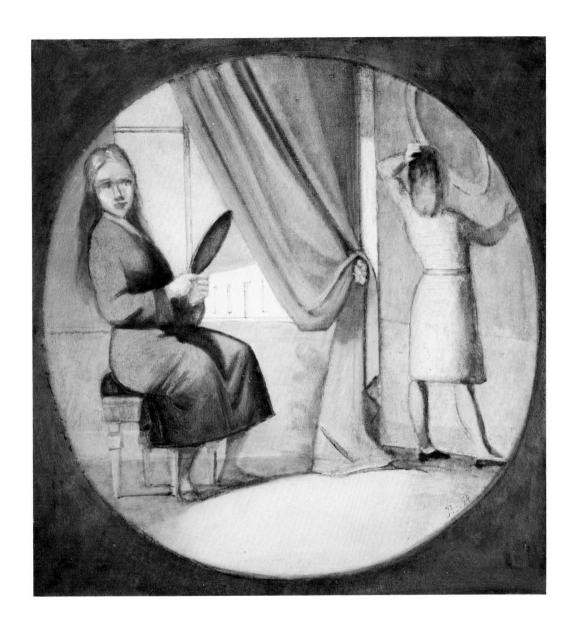

BALTHUS b. 1908

22 *Early Morning.* 1954
Oil on canvas, 29⅝ x 28⅝" (75.5 x 73 cm.)
Courtesy Marlborough Gallery, New York

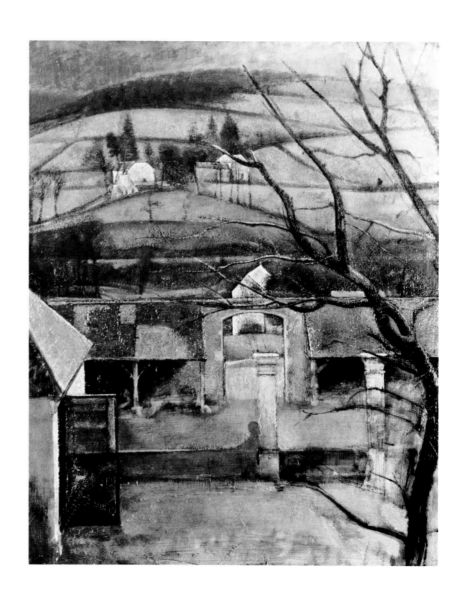

BALTHUS

23 *Landscape at Chassy (Winter) (Paysage à Chassy [l'hiver]).* 1954
Oil on canvas, 39¾ x 32" (100 x 81 cm.)
Courtesy Gallery Claude Bernard Inc.

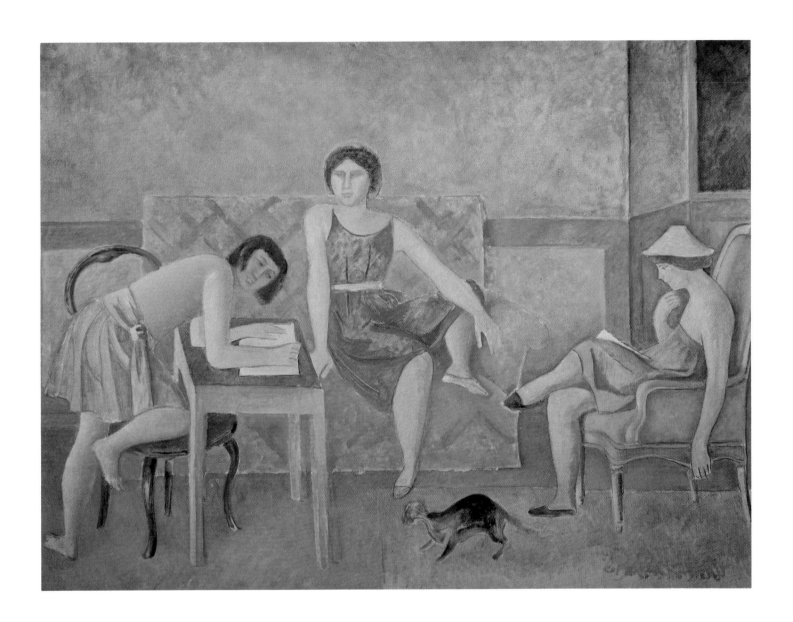

BALTHUS

24 *Three Sisters (Les Trois soeurs).* 1966
Oil on canvas, 51½ x 69" (131 x 175 cm.)
Courtesy Thomas Ammann Fine Art, Zürich

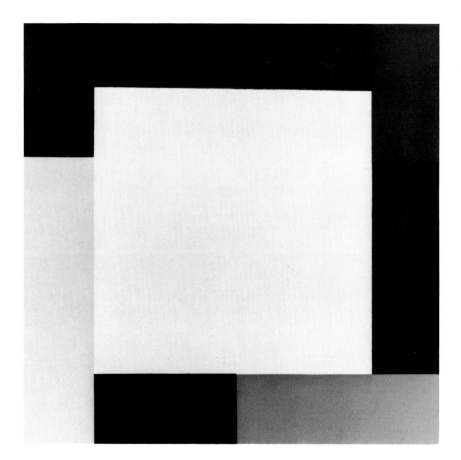

MAX BILL b. 1908

25 *Colored and Black Group Around White (Farbige und
 Schwarze Gruppe um Weiss).* 1967
 Oil on canvas, 15¾ x 15¾" (40.1 x 40.1 cm.)
 Collection The Solomon R. Guggenheim Museum, New York
 Bequest of Sibyl H. Edwards, with life interest retained by
 William C. Edwards, Jr., 1980
 81.2765

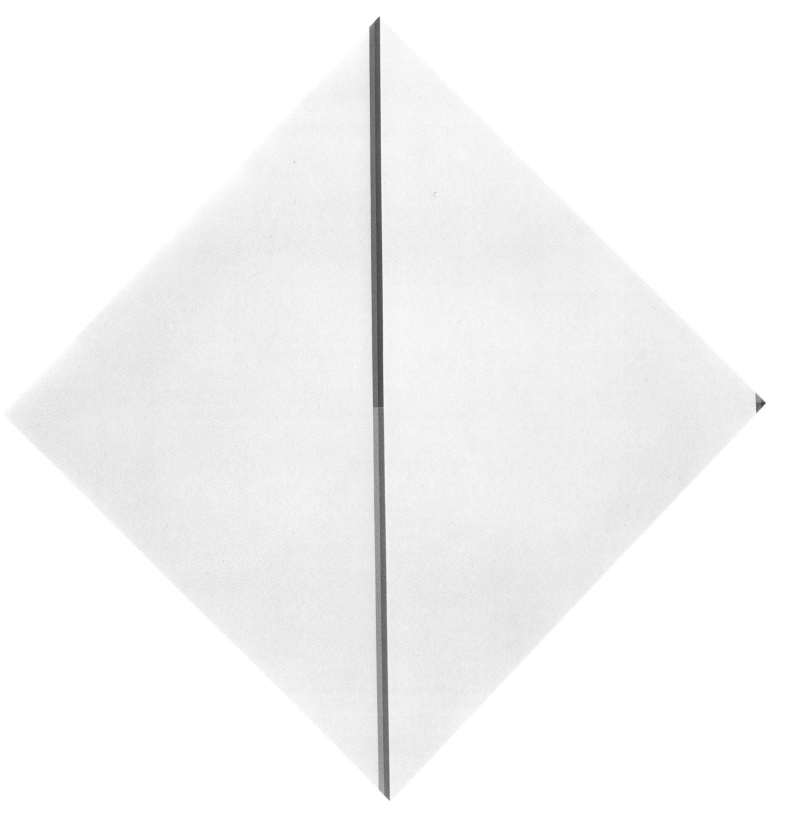

MAX BILL

26 *Parallels of Double Colors in Space (Parallelen im Raum
 aus Doppelfarben).* 1970-73
 Oil on canvas, lozenge, 83½ x 83½″ (211.5 x 211.5 cm.)
 Collection The Solomon R. Guggenheim Museum, New York
 Purchased with funds contributed by William C. Edwards,
 Jr. in memory of Sibyl, 1981
 81.2784

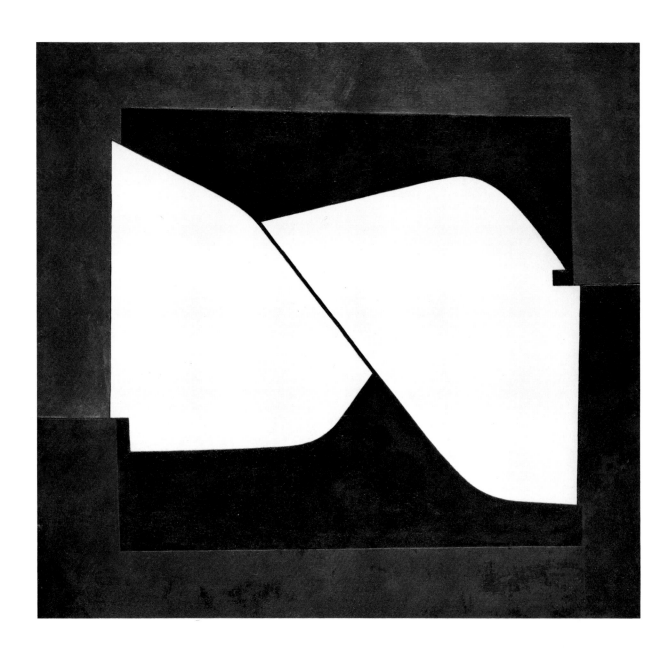

VICTOR VASARELY b. 1908

27 *Kandahar.* 1950-52
Oil on pressed wood, 39⅜ x 42⅝" (100 x 108.3 cm.)
Collection The Solomon R. Guggenheim Museum, New York
54.1396

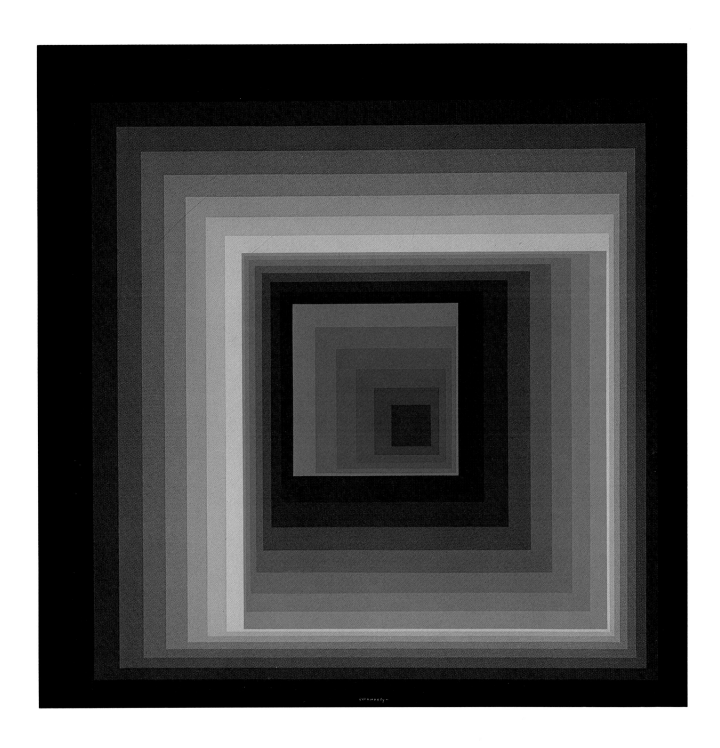

VICTOR VASARELY

28 *Reytey.* 1968
Tempera on canvas, 63 x 63″ (160 x 160 cm.)
Collection The Solomon R. Guggenheim Museum, New York
73.2042

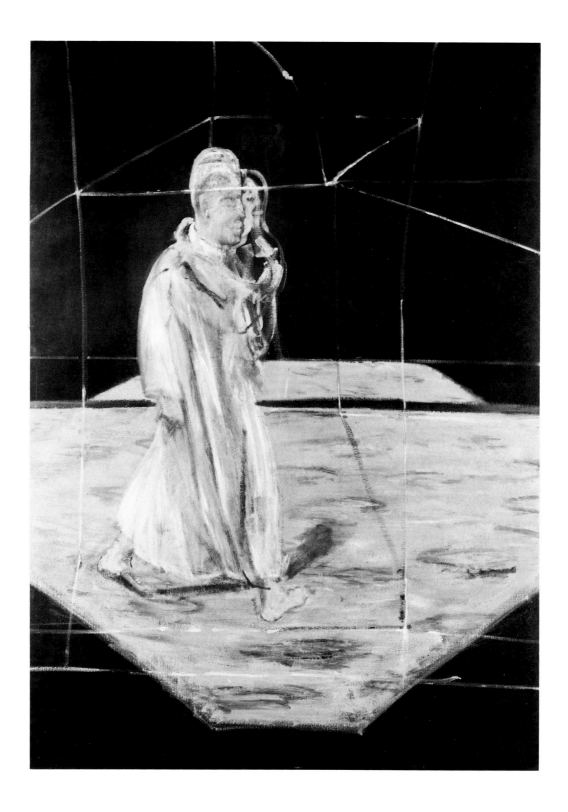

FRANCIS BACON b. 1909

29 *Man Carrying a Child.* 1956
 Oil on canvas, 78 x 56" (198.2 x 142 cm.)
 Collection Julian J. Aberbach

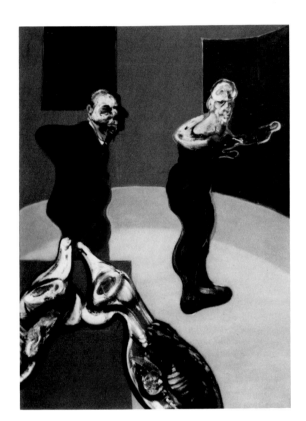 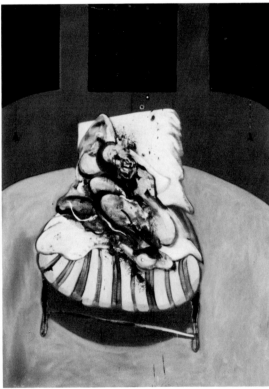 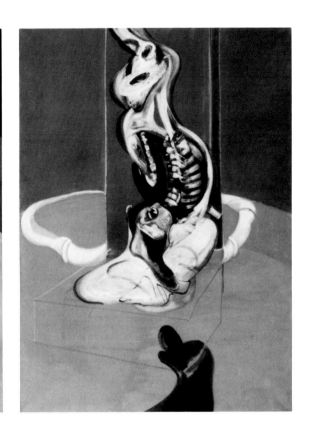

FRANCIS BACON

30 *Three Studies for a Crucifixion.* March 1962
 Oil with sand on canvas, three panels, each 78 x 57" (198.2 x 144.8 cm.)
 Collection The Solomon R. Guggenheim Museum, New York
 64.1700

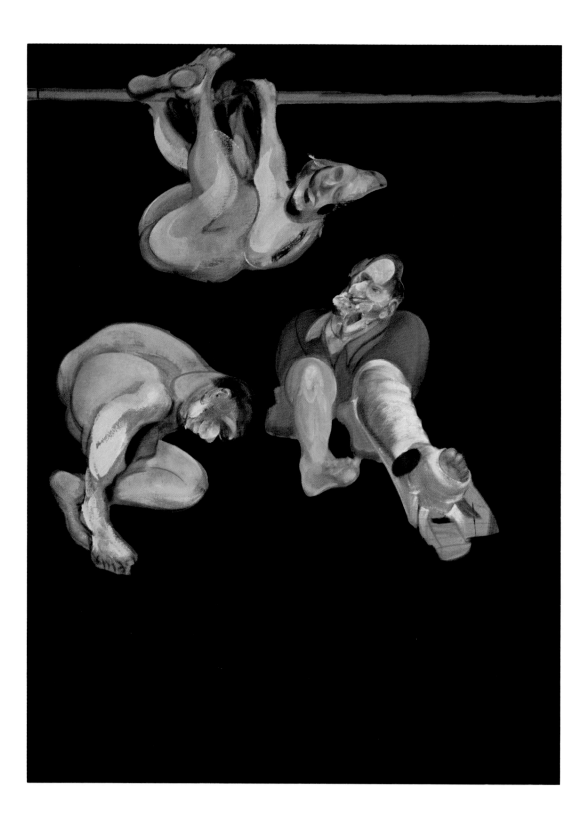

FRANCIS BACON

31 *Three Studies from the Human Body.* 1967
Oil on canvas, 78 x 58″ (198.2 x 147 cm.)
Courtesy Gallery Claude Bernard Inc.

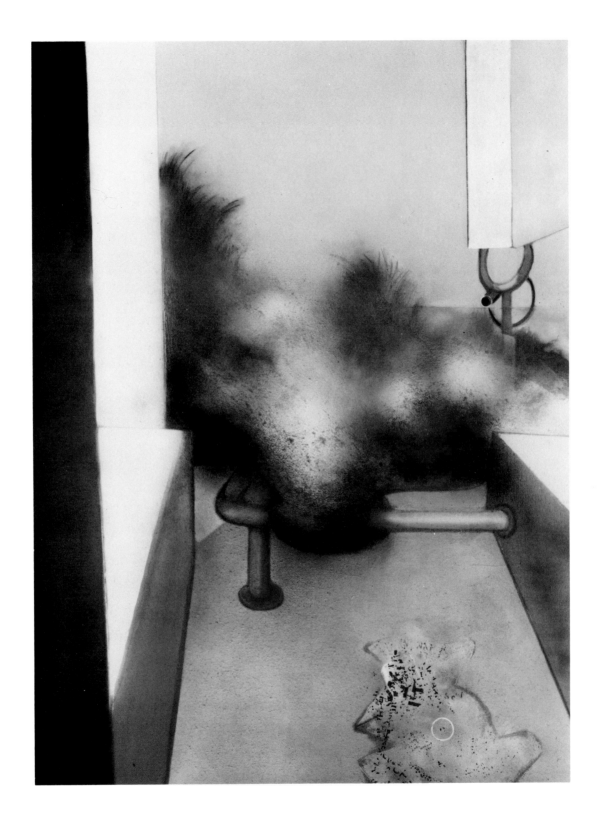

FRANCIS BACON

32 *Sand Dune.* 1981
Oil and pastel on canvas, 78 x 58" (198.2 x 147 cm.)
Courtesy Marlborough Gallery, New York

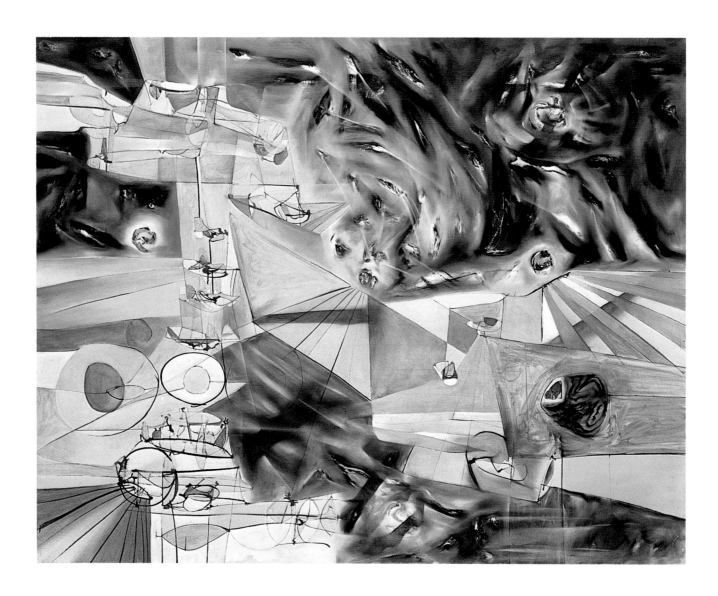

MATTA b. 1911

33 *Years of Fear.* 1941
Oil on canvas, 44 x 56" (111.8 x 142.2 cm.)
Collection The Solomon R. Guggenheim Museum, New York
72.1991

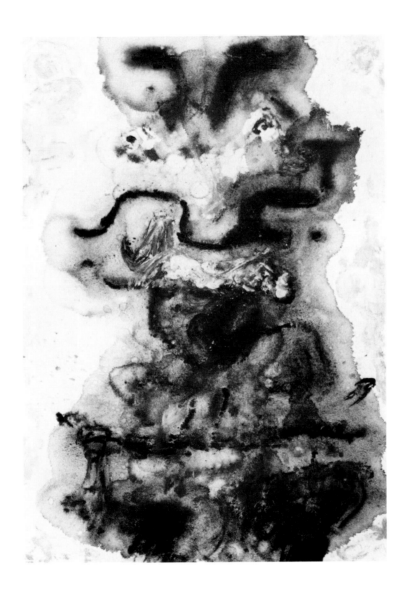

ASGER JORN 1914-1973

34 *Untitled.* 1956
 Oil on canvas, 39⅜ x 27⅜" (101 x 70.5 cm.)
 Collection Mrs. Hannelore B. Schulhof

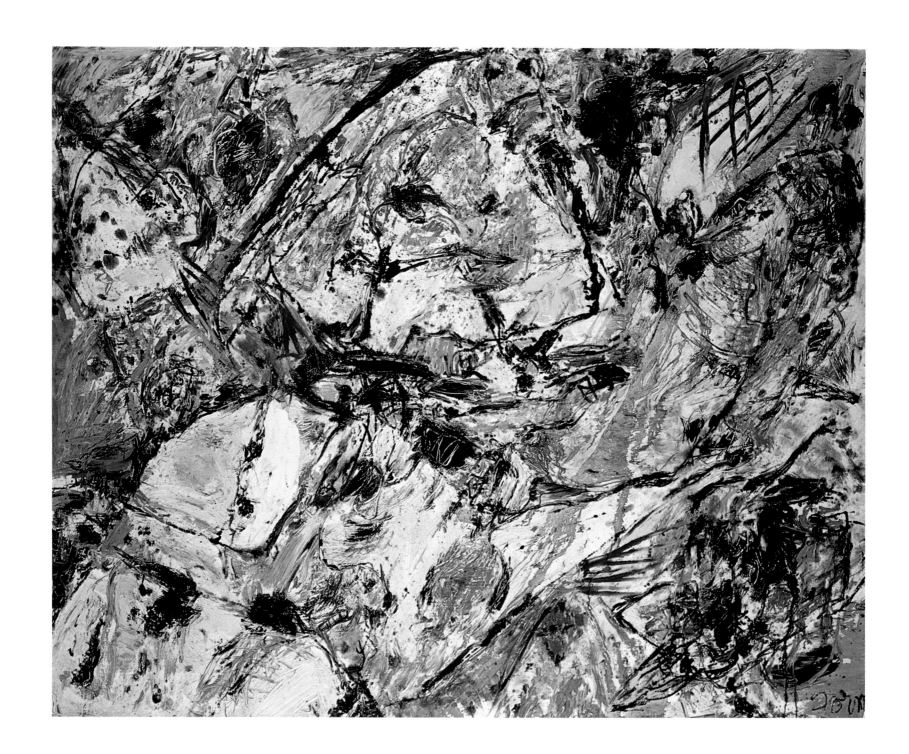

ASGER JORN

35 *Soul for Sale.* 1958-59
Oil on canvas, 79 x 98¾″ (201 x 251 cm.)
Courtesy Galerie Rudolf Zwirner, Cologne

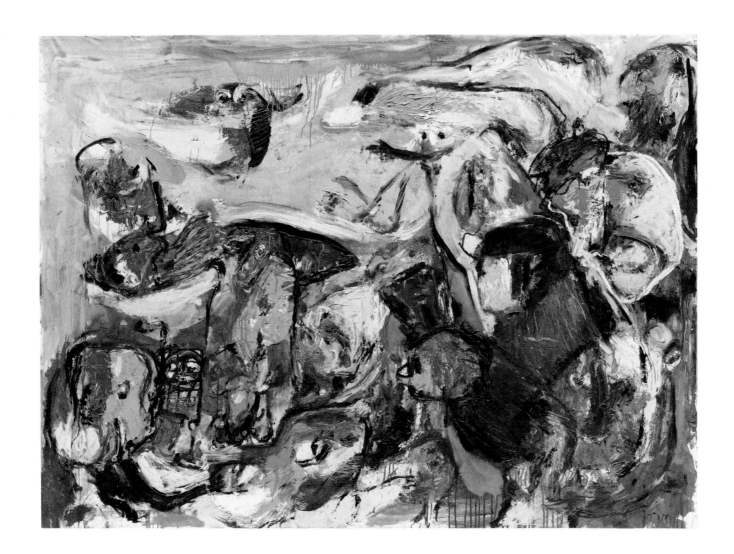

ASGER JORN

36 *Green Ballet (Il balletto verde).* 1960
Oil on canvas, 57⅛ x 78⅞" (145 x 200 cm.)
Collection The Solomon R. Guggenheim Museum, New York
62.1608

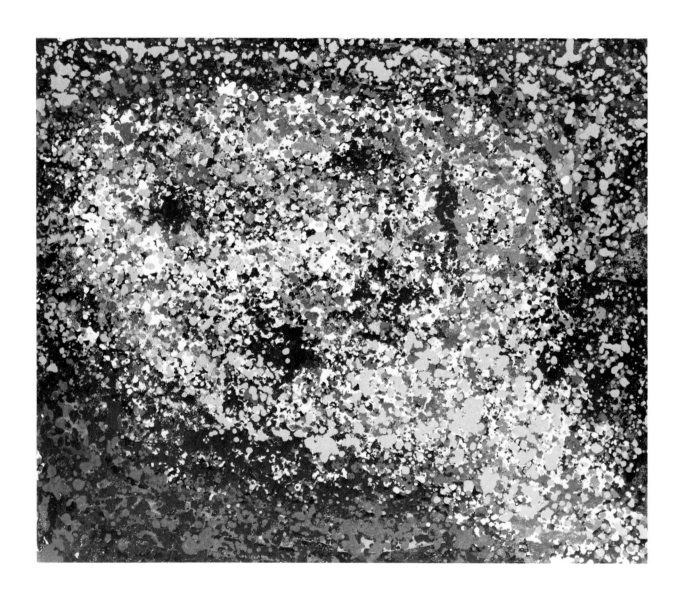

ASGER JORN

37 *Enobargar.* 1961-62
 Oil on canvas, 21 x 25½" (53.5 x 64.9 cm.)
 Collection The Solomon R. Guggenheim Museum,
 New York
 Gift of Robert Elkon, 1982
 82.2974

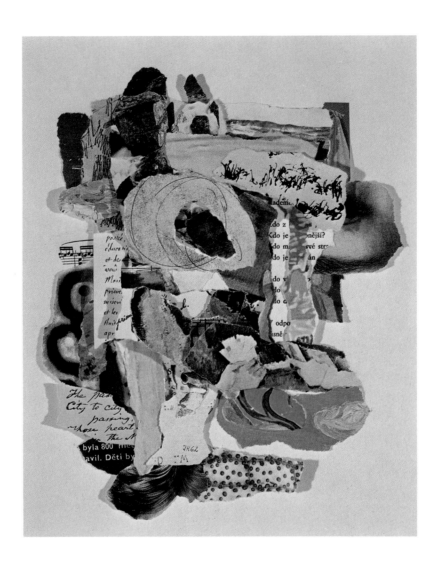

JIŘÍ KOLÁŘ b. 1914

38 *Poem for the Wind II.* 1962
 Paper ventillage mounted on paper, 18½ x 13⅜" (47 x 34 cm.)
 Collection The Solomon R. Guggenheim Museum, New York
 75.2155

JIŘÍ KOLÁŘ

39 *Song About Mr. G.* 1967
Intercollage and chiasmage, 11¾ x 8½ " (30 x 21.5 cm.)
Collection The Solomon R. Guggenheim Museum, New York
Gift, Mr. and Mrs. William C. Edwards, Jr., 1977
77.2344

JIŘÍ KOLÁŘ

40 *An Apple for Mr. K.* 1972
Chiasmage, 15½ x 11½" (39.4 x 29.2 cm.)
Collection The Solomon R. Guggenheim Museum, New York
Gift, Mr. and Mrs. William C. Edwards, Jr., 1977
77.2367

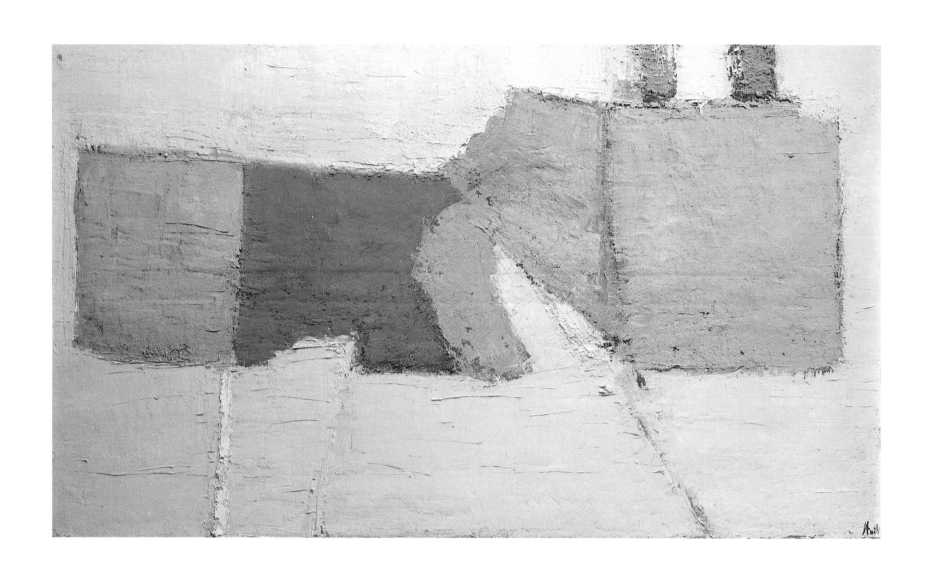

NICOLAS DE STAËL 1914-1955

41 *Composition in Gray and Blue (Composition en gris et en bleu).* 1950
Oil on canvas, 45½ x 77″ (115 x 195 cm.)
Private Collection

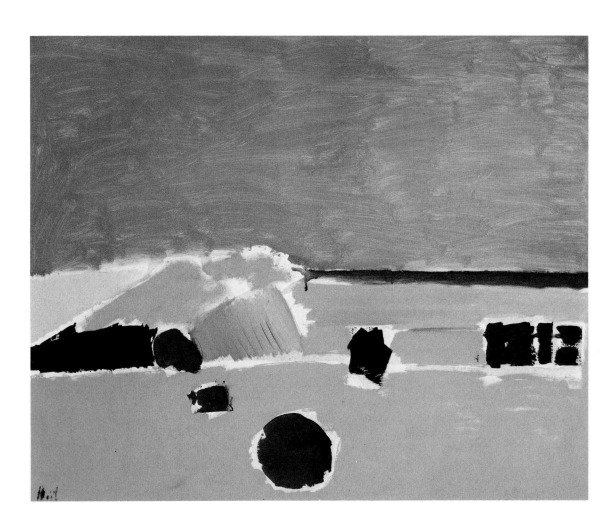

NICOLAS DE STAËL

42 *The Beach at Agrigente.* 1954
Oil on canvas, 31⅞ x 39½″ (80.5 x 100.5 cm.)
Courtesy Acquavella Galleries Inc., New York

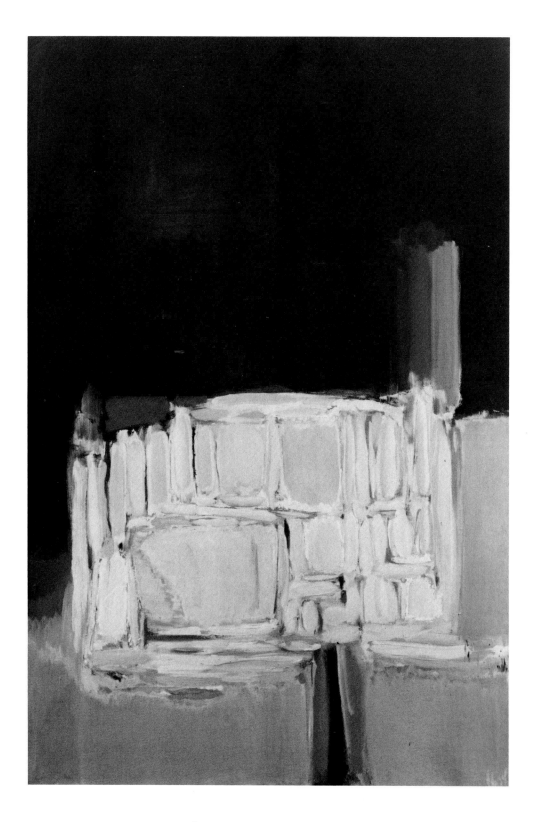

NICOLAS DE STAËL

43 *The Cathedral (La Cathédrale).* 1955
 Oil on canvas, 77 x 51¼″ (195 x 130 cm.)
 Private Collection

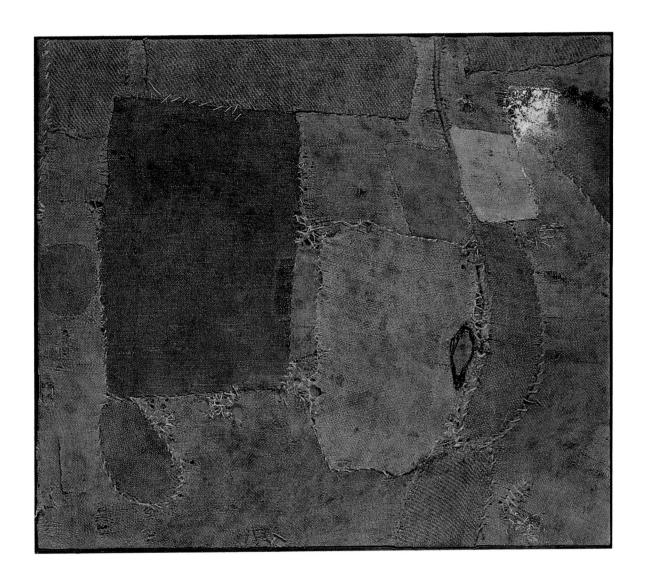

ALBERTO BURRI b. 1915

44 *Composition (Composizione).* 1953
Oil, gold paint and glue on burlap and canvas, 33⅞ x 39⅜″ (87.6 x 100 cm.)
Collection The Solomon R. Guggenheim Museum, New York
53.1364

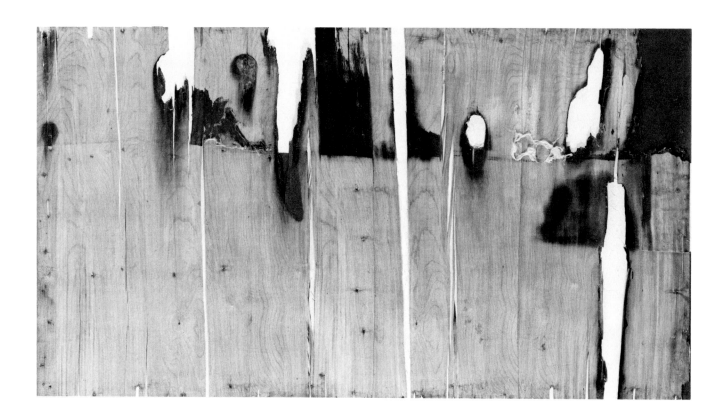

ALBERTO BURRI

45 *Wood and White 1 (Legno e Bianco 1).* 1956
Oil, tempera and wood on canvas, 34½ x 62⅝″ (87.5 x 159.5 cm.)
Collection The Solomon R. Guggenheim Museum, New York
57.1463

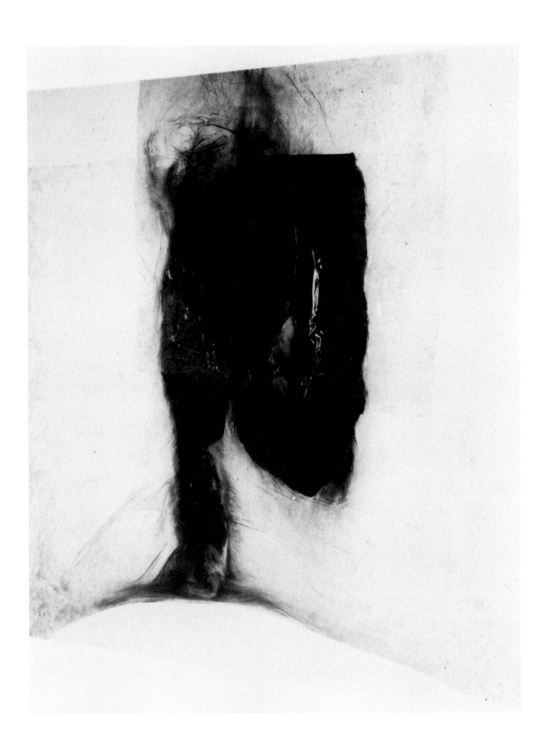

ALBERTO BURRI

46 *White B1 (Bianco B1).* 1965
 Smoke and oil with plastic on Masonite, 59½ x 59½″ (151 x 151 cm.)
 Collection Mrs. Hannelore B. Schulhof

RICHARD HAMILTON b. 1922

47 *The Solomon R. Guggenheim (Black).* 1965-66
Fiberglas and cellulose, 48 x 48 x 7½" (122 x 122 x 19 cm.)
Collection The Solomon R. Guggenheim Museum, New York
67.1859.1

RICHARD HAMILTON

48 *The Solomon R. Guggenheim (Black and White).* 1965-66
Fiberglas and cellulose, 48 x 48 x 7½" (122 x 122 x 19 cm.)
Collection The Solomon R. Guggenheim Museum, New York
67.1859.2

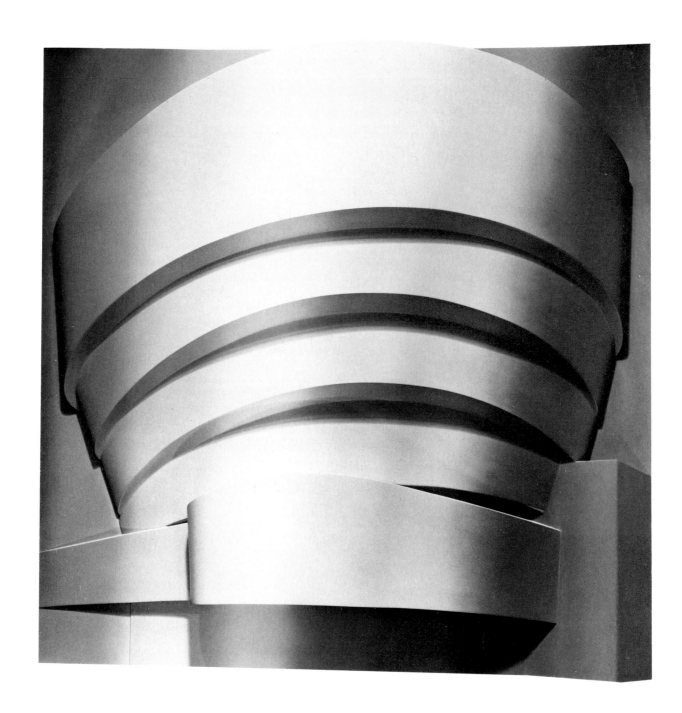

RICHARD HAMILTON

49 *The Solomon R. Guggenheim (Spectrum).* 1965-66
Fiberglas and cellulose, 48 x 48 x 7½" (122 x 122 x 19 cm.)
Collection The Solomon R. Guggenheim Museum, New York
67.1859.3

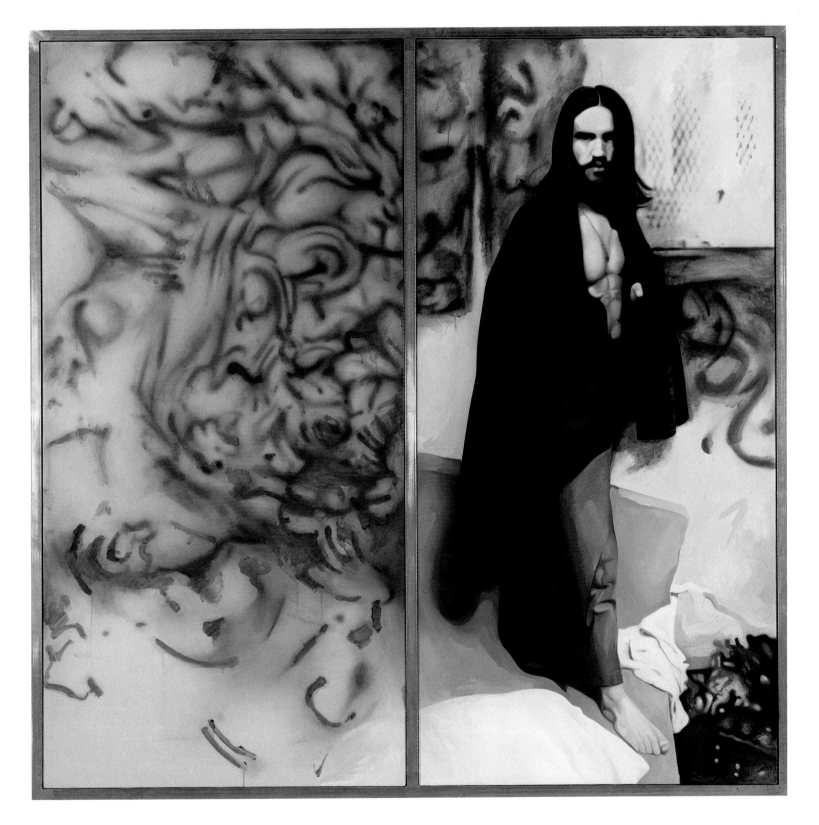

RICHARD HAMILTON

50 *The citizen.* 1981-83
Oil on canvas, 2 sections, each 78¾ x 39¼″ (200 x 100 cm.)
Collection of the artist

ANTONI TÀPIES b. 1923

51 *Great Painting (Gran pintura).* 1958
Mixed media on canvas, 78½ x 103" (199.3 x 261.6 cm.)
Collection The Solomon R. Guggenheim Museum, New York
59.1551

ANTONI TÀPIES

52 *Large Brown Diptych (Gran dîptic marró).* 1978
Mixed media on canvas, 76¾ x 134″ (195 x 340 cm.)
Collection Mrs. Hannelore B. Schulhof

PIERRE ALECHINSKY b. 1927

53 *Ant Hill (La Fourmilière).* 1954
Oil on canvas, 59½ x 93⅞″ (151 x 238 cm.)
Collection The Solomon R. Guggenheim Museum, New York
57.1462

PIERRE ALECHINSKY

54 *Vanish (Disparaître).* 1959
Oil on canvas, 78¾ x 110¼″ (200 x 280 cm.)
Collection The Solomon R. Guggenheim Museum, New York
Gift, Julian and Jean Aberbach, New York, 1967
67.1848

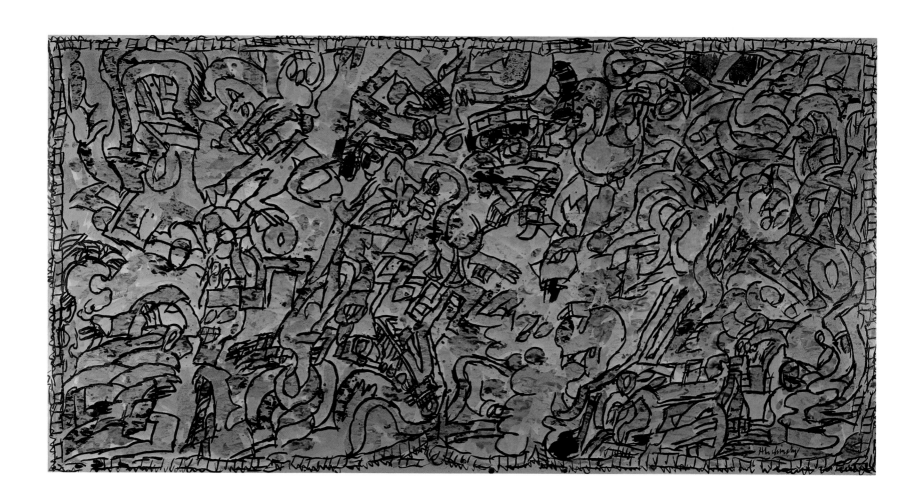

PIERRE ALECHINSKY

55 *Codex.* 1981
Acrylic on paper mounted on canvas, 60½ x 118" (153.5 x 300 cm.)
Courtesy Lefebre Gallery, New York

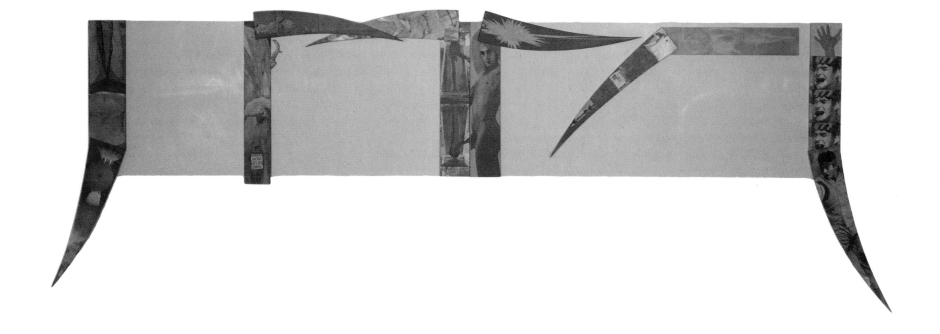

ÖYVIND FAHLSTRÖM 1928-1976

56 *Life-Span No. 3 (Marilyn Monroe).* 1967
Variable painting of oil and enamel on photograph and vinyl, 20⅛ x 100"
(51 x 254 cm.)
Collection Mr. William H. Wise, Palm Springs, California

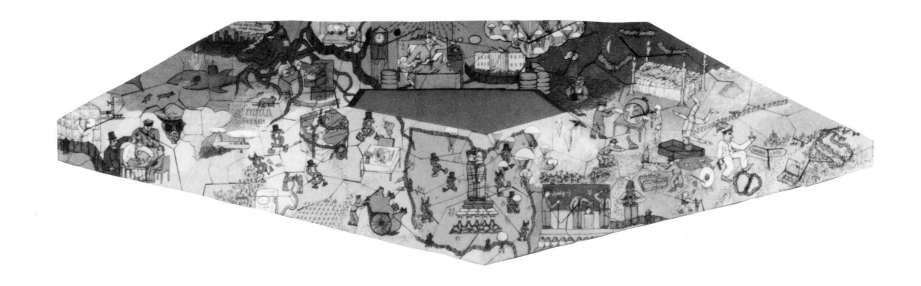

ÖYVIND FAHLSTRÖM

57 *Pentagon Puzzle.* 1970
Variable painting of magnetic elements and acrylic on
vinyl and metal board, 31⅛ x 40³/₁₆″ (79.5 x 102 cm.)
Courtesy Sidney Janis Gallery, New York

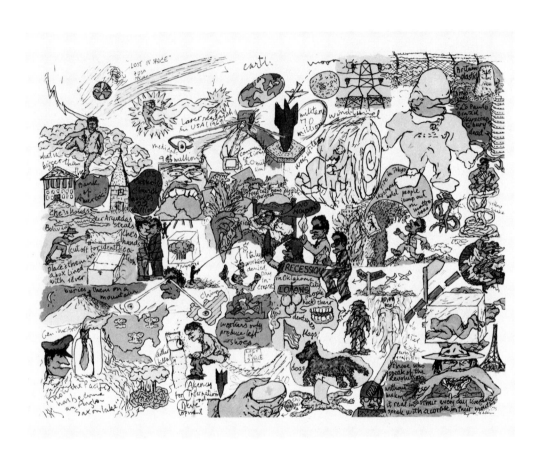

ÖYVIND FAHLSTRÖM

58 *Early Notes B.* 1971-74
 Acrylic and·ink on paper, 9 x 11⅞″ (23 x 30 cm.)
 Promised gift, The Kempe Collection

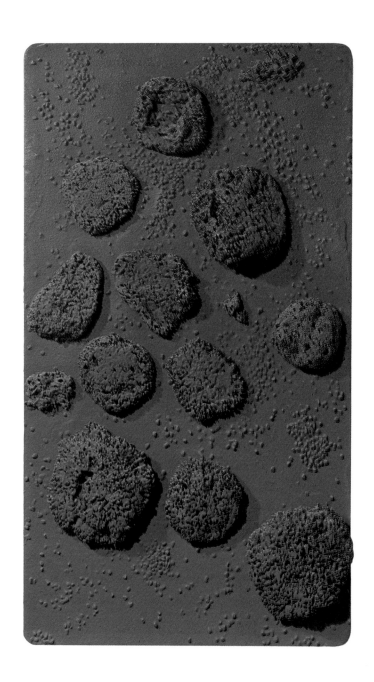

YVES KLEIN 1928-1962

59 *Sponge RE 15.* ca. 1960
Dry pigment in synthetic resin on sponge, 42½ x 24″ (104.9 x 61 cm.)
Courtesy Castelli Feigen Corcoran, New York

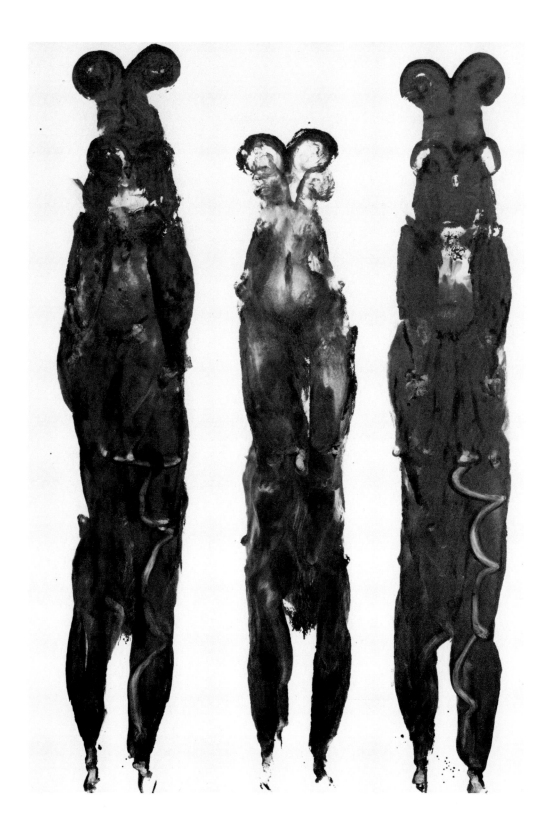

YVES KLEIN

60 *Celebration of a New Era (Célébration d'une nouvelle ère)*
 (ANT 89). 1961
 Dry blue pigment in synthetic resin on paper mounted on fabric,
 87½ x 60¾" (222.2 x 154.5 cm.)
 Courtesy Castelli Feigen Corcoran, New York

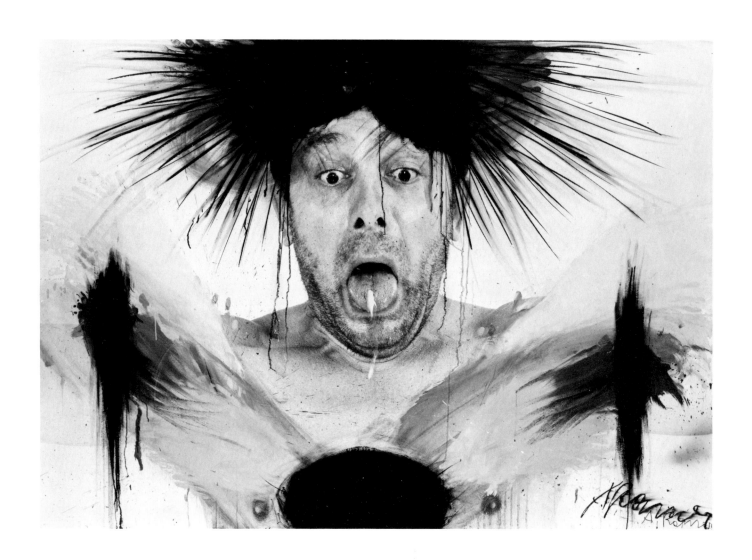

ARNULF RAINER b. 1929

61 *Schreck.* 1970-73
Oil on photographic paper mounted on wood, 48 x 70″ (122 x 175 cm.)
Collection of the artist

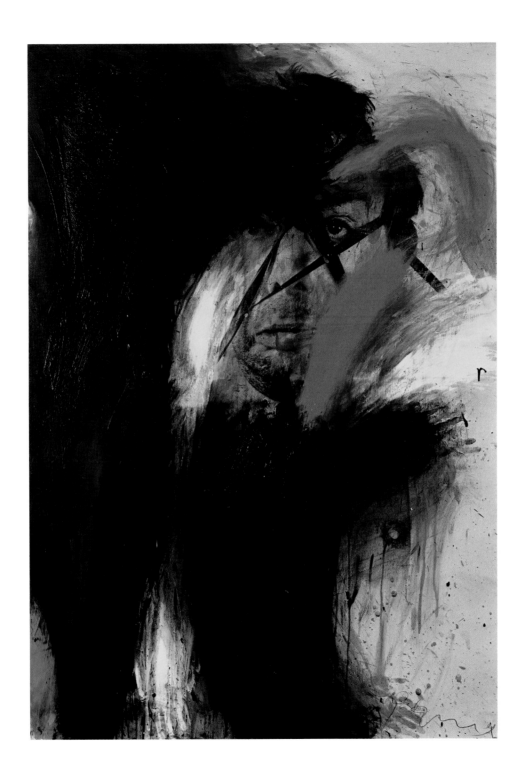

ARNULF RAINER

62 *Untitled.* 1974
 Oil on photo linen, 68 x 46" (170 x 120 cm.)
 Collection of the artist

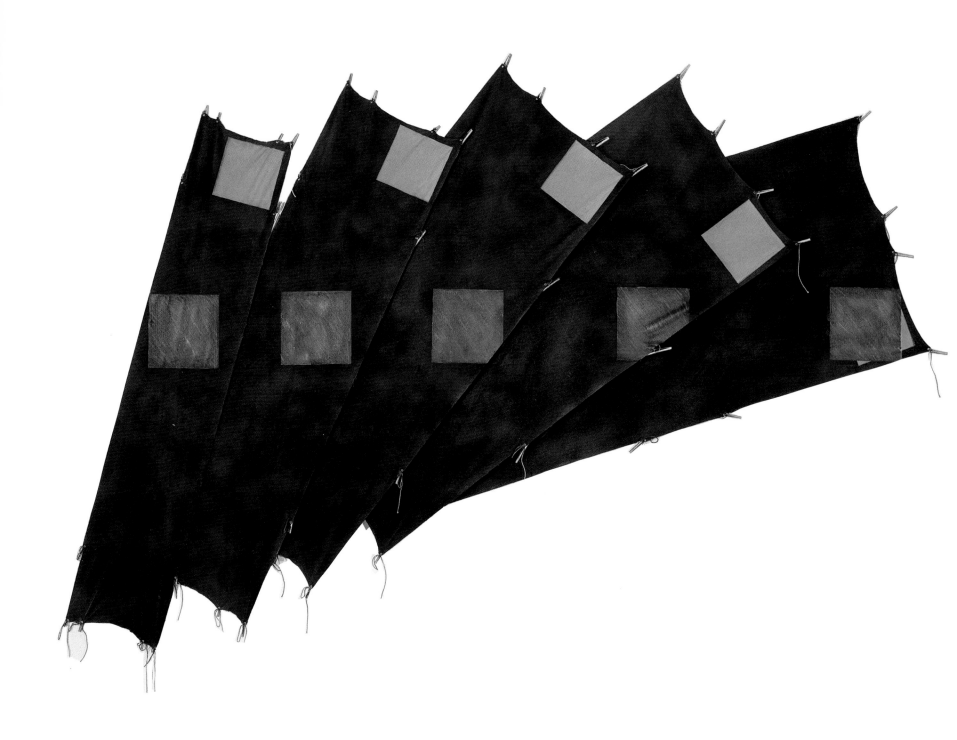

RICHARD SMITH b. 1931

63 *Working Week 5 (For Charles Mingus).* 1979
 Acrylic and polyurethane on canvas, 106 x 146" (269.2 x 371 cm.)
 Collection The Solomon R. Guggenheim Museum, New York
 Partial gift, Mr. and Mrs. William C. Edwards, Jr., 1980
 80.2680 A-E

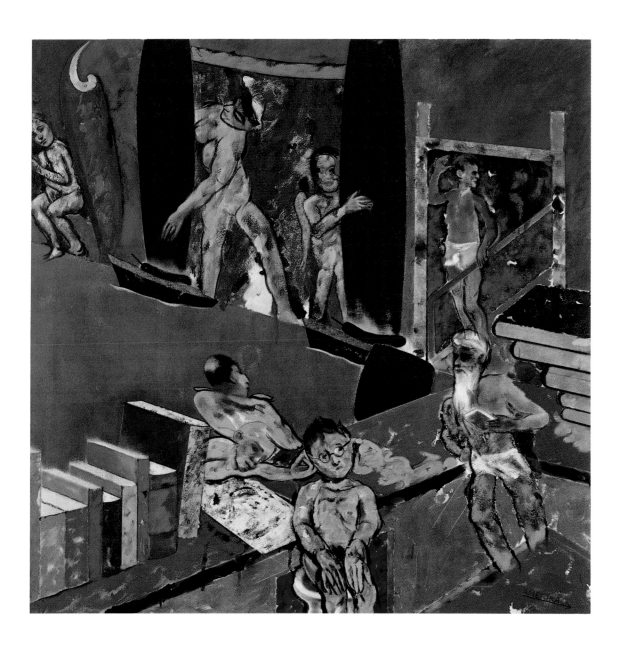

R.B. KITAJ b. 1932

64 *London, England (Bathers).* 1982
Oil on canvas, 48 x 48" (122 x 122 cm.)
Courtesy Marlborough Gallery, New York

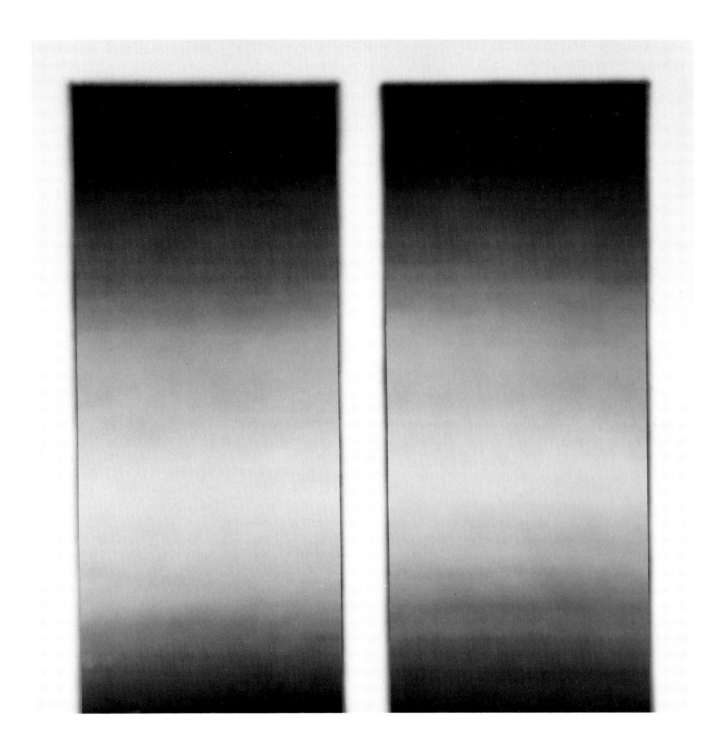

GERHARD RICHTER b. 1932

65 *Passage (Durchgang).* 1968
 Acrylic on canvas, 78¾ x 78¾″ (200 x 200 cm.)
 Collection The Solomon R. Guggenheim Museum, New York
 Gift, Theodoron Foundation, 1969
 69.1904

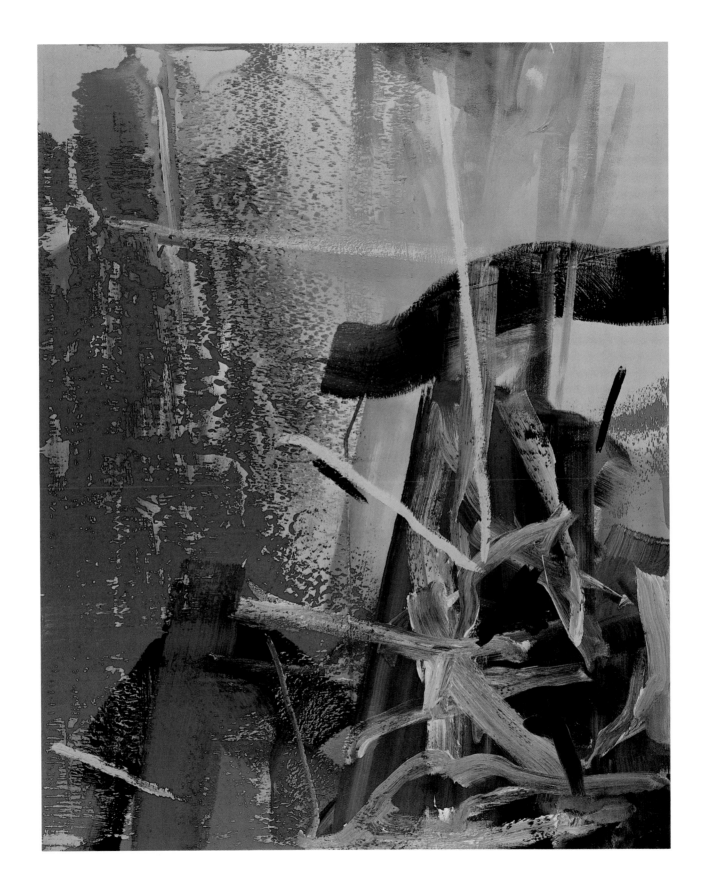

GERHARD RICHTER

66 *Korn.* 1982
Oil on canvas, 98¼ x 78¾″ (250 x 200 cm.)
Courtesy Sperone Westwater Fischer Inc., New York

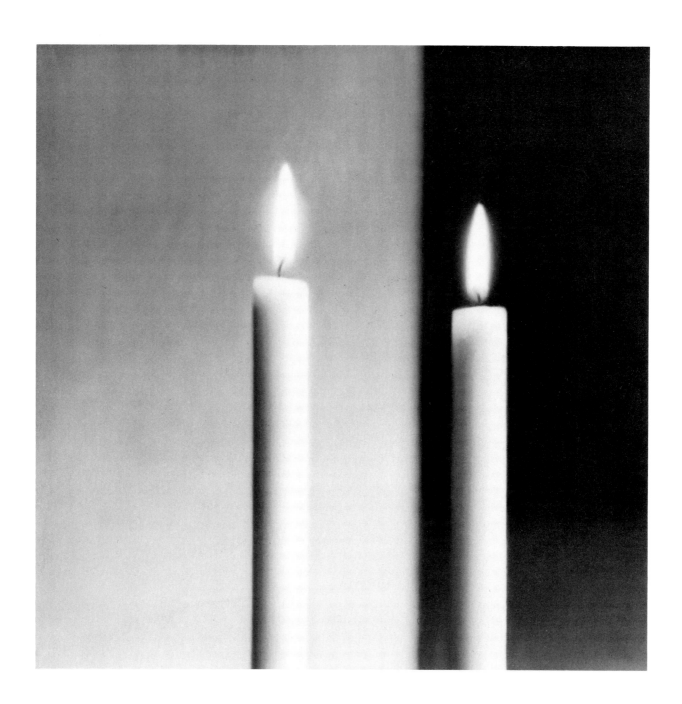

GERHARD RICHTER

67 *Two Candles (Zwei Kerzen)*. 1982
 Oil on canvas, 55¼ x 55¼" (140 x 140 cm.)
 Collection Jerry and Emily Spiegel, New York

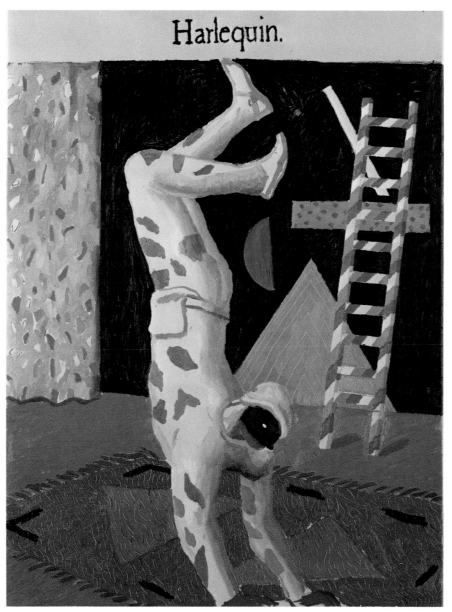

©David Hockney

DAVID HOCKNEY b. 1937

68 *Harlequin.* 1980
Oil on canvas, 48 x 36" (122 x 90.2 cm.)
Courtesy André Emmerich Gallery Inc., New York

Alechinsky at Clot Bramsen and
Georges Printing Works, 1974

Miró, Bacon and Masson at opening
of Bacon's retrospective at Grand
Palais, Paris, October 26, 1971

Biographies

PIERRE ALECHINSKY b. 1927

Pierre Alechinsky was born on October 19, 1927, in Brussels. From an early age Alechinsky was interested in graphic arts and in 1944 he entered the Ecole Nationale Supérieure d'Architecture et des Arts Décoratifs in Brussels, where he studied book illustration and typography. He also painted in a post-Cubist style and later in a manner reminiscent of Ensor. His paintings of monstrous women were shown in his first one-man exhibition at the Galerie Lou Cosyn in Brussels in 1947. That same year he became a member of the group *Jeune Peinture Belge.*

In 1948 expressionist artists including Karel Appel, Jorn, Constant, Carl-Henning Pedersen and Corneille formed the COBRA group. Alechinsky joined COBRA in 1949 and participated in the first *Internationale tentoonstelling experimentele Kunst—COBRA* that year at the Stedelijk Museum in Amsterdam. He became a central figure in the group and organized its second international exhibition in Liège, Belgium, in 1951. Shortly thereafter COBRA disbanded but the group's commitment to spontaneous expression and figuration continued to be reflected in Alechinsky's work.

Alechinsky moved to Paris in 1951 to study printmaking under a grant from the French government. He studied engraving with Stanley William Hayter at Atelier 17 in 1952. At about the same time he became fascinated by Japanese calligraphy and in 1955 he went to Tokyo and Kyoto. There he visited masters of the art and produced the award-winning film *Calligraphie japonaise.* In the 1960s Alechinsky traveled extensively in Europe, the United States and Mexico and participated in numerous international exhibitions. An Alechinsky retrospective organized by The Arts Club of Chicago toured the United States in 1965. In 1976 Alechinsky became the first recipient of the prestigious Andrew W. Mellon Prize for artists. The prize was accompanied by a major retrospective of his work in all media at the Museum of Art, Carnegie Institute, Pittsburgh, in 1977. The artist continues to paint and to make prints and book illustrations at his home in Bougival, France.

FRANCIS BACON b. 1909

Francis Bacon was born in Dublin on October 28, 1909. At the age of sixteen he moved to London and subsequently lived for about two years in Berlin and Paris. Although Bacon never attended art school he began to draw and work in watercolor about 1926-27. Picasso's work decisively influenced his painting until the mid-1940s. Upon his return to London in 1929 he established himself as a furniture designer and interior designer. He began to use oils in the autumn of that year and exhibited furniture and rugs as well as a few paintings in his studio. His work was included in a group exhibition in London at the Mayor Gallery in 1933. In 1934 the artist organized his own first one-man show at Sunderland House, London, which he called Transition Gallery for the occasion. He participated in a group show at Thos. Agnew and Sons in London in 1937.

Bacon painted relatively little after his one-man show and in the 1930s and early 1940s destroyed many of his works. He began to paint intensively again in 1944. His first major one-man show took place at the Hanover Gallery in London in 1949. From the mid-1940s to the 1950s Bacon's work revealed the influence of Surrealism and his predilection for figures in interior spaces. He avoids the static image of traditional figure painting and attempts to show his subjects in motion, frequently using blurring to suggest mobility. Since the mid-1960s his canvases reveal

a greater sense of depth, brighter and more varied colors and the use of foreshortened, twisted forms to create a nightmare vision. In the 1950s Bacon drew on such sources as Velázquez's *Portrait of Pope Innocent X*, van Gogh's *The Painter on the Road to Tarascon* and Muybridge's photographs. His first one-man exhibition outside England was held in 1953 at the Durlacher Brothers, New York. In 1950-51 and 1952 the artist traveled to South Africa. He visited Italy in 1954 when his work was featured in the British Pavilion at the Venice Biennale. His first retrospective was held at the Institute of Contemporary Art, London, in 1955. Bacon was given a one-man show at the São Paulo Bienal in 1959. In 1962 the Tate Gallery, London, organized a major Bacon retrospective, a modified version of which traveled to Mannheim, Turin, Zürich and Amsterdam. Other important exhibitions of his work were held at The Solomon R. Guggenheim Museum, New York, in 1963 and the Grand Palais in Paris in 1971; paintings from 1968 to 1974 were exhibited at The Metropolitan Museum of Art, New York, in 1975. The artist lives in London.

BALTHUS b. 1908

Balthazar Klossowski de Rola was born on February 29, 1908, in Paris, of aristocratic Polish parents who were active in the arts. The family settled in Geneva in 1914. When Balthus was twelve, an album of his drawings was published with a foreword by Rainer Maria Rilke, a family friend who became the artist's cultural mentor. In 1924 Balthus settled in Paris to study painting. Essentially self-taught, he copied Piero, Poussin and other masters at the Louvre. When he was seventeen Balthus traveled in Italy with André Gide. He served in the military in Morocco from 1929 until 1933.

His mature style, a realism based in a private vision, emerged in the thirties: he depicts strange, dreamlike environments inhabited by adolescent girls, tinged with eroticism and sometimes violence. Intermittently throughout his career, Balthus has also executed more naturalistic works, primarily landscapes reminiscent of Courbet. The artist's first one-man show took place at the Galerie Pierre in Paris in 1934. The following year he designed sets and costumes for Antonin Artaud's production of *The Cenci* in Paris. His first one-man show in New York was held at the Pierre Matisse Gallery in 1938. In 1939 Balthus enlisted in the army but was discharged because of poor health. The next year he settled in Champrovent in Savoie, and in 1943 moved to Switzerland, first to Bern and then to Fribourg. In 1946 Balthus returned to Paris, where he became friendly with André Malraux and Albert Camus. From 1954 to 1961 Balthus lived in the Morvan region of France and often visited Italy.

His first major retrospective occurred at The Museum of Modern Art in New York in 1956, and attracted international attention. In 1966 a retrospective of his work took place at the Musée des Arts Décoratifs in Paris, and in 1968 a major Balthus exhibition was presented at the Tate Gallery, London. Balthus was Director of the Académie de France in Rome from 1961 until 1977; during his tenure he made several trips to Japan. He was honored with a one-man show at the Venice Biennale in 1980. The artist currently lives and works in Italy and Switzerland.

MAX BILL b. 1908

Max Bill was born on December 22, 1908, in Winterthur, Switzerland. He apprenticed as a silversmith at the Kunstgewerbeschule in Zürich from 1924 to 1927. In 1927 he entered the Bauhaus at Dessau, where he studied architecture, painting and other disciplines until 1928. The following year he returned to Zürich to work as an architect, painter, graphic designer, and later as a sculptor, writer and product designer. He was also a theorist and teacher in these fields.

Bill moved to Paris in 1932; here he met Piet Mondrian, Jean Arp and Georges Vantongerloo. He associated with the *Abstraction-Création* group from 1932 until its dissolution in 1936. Bill produced his first sculptures in 1933, and executed the *Endless Ribbon*, his first single-sided sculpture, in 1935. In his text "Konkrete Kunst," which appeared in 1938, Bill proposed that con-

crete art is created according to the techniques and laws of art, without reliance on nature, and that the instruments of this realization are color, space, light and movement. Also in 1938 Bill completed *Fifteen Variations on a Single Theme*, a series of prints that reflects his penchant for elaborating single subjects in numerous coloristic variations. It reveals as well his characteristic style of reduced geometric forms and precise, mathematically determined structure.

Between 1939 and 1945 Bill served intermittently in the military. From 1951 to 1956 he was Director of the Departments of Architecture and Design at the Hochschule für Gestaltung in Ulm, an institution he cofounded. The artist was awarded the Grand Prize at the Milan Triennale in 1951 and the Grand Prize for Sculpture at the São Paulo Bienal the same year, and in 1958 his work was included in the Venice Biennale. In 1960 Bill organized an exhibition of concrete art at the Helmhaus in Zürich. He was named Honorary Fellow of the American Institute of Architects in 1964 and from 1967 until 1974 held the Chair of Environmental Design at the Staatliche Hochschule für Bildende Kunst in Hamburg. Bill was a member of the Swiss Parliament in Bern from 1967 to 1971. The Albright-Knox Art Gallery in Buffalo organized a major retrospective of his work that traveled in the United States in 1974-75. The artist lives and works in Bern.

Bissier at Café Schiff, Ascona, Switzerland

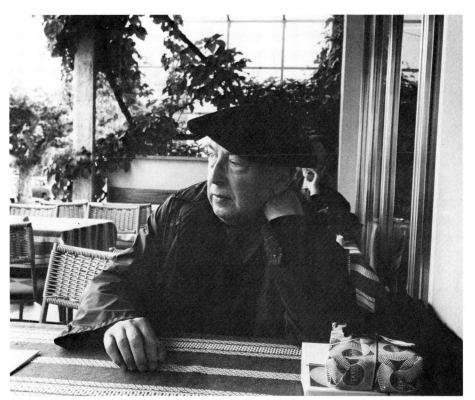

JULIUS BISSIER 1893-1965

Julius Heinrich Bissier was born on December 3, 1893, in Freiberg-im-Breisgau, Germany. He first studied art history at the University in his native city in 1913 but decided to become an artist and enrolled in the Kunstakademie Karlsruhe the following year. His artistic training was cut short after a few months by World War I; after serving throughout the conflict, Bissier began to paint independently. Bissier's first one-man show was held at the Kunstverein, Freiburg-im-Breisgau, in 1920. He was awarded the Prize for Painting at the Deutsche Künstlerbund exhibition in Hannover in 1928. He taught at the University of Freiburg-im-Breisgau from 1929 to 1933. The Orientalist Ernst Grosse introduced Bissier to Far Eastern art, and Willi Baumeister stimulated his interest in modern abstract painting. He visited Paris and met Constantin Brancusi in 1933. In the early 1930s Bissier made his first abstract brush paintings, a form of expression to which he devoted himself almost exclusively from 1932 to 1947.

The artist's long friendship with Oskar Schlemmer began in 1933. Bissier did not exhibit between 1933 and 1945 because of the political situation. In 1934 nearly all of his work was destroyed in a fire at the University of Freiburg-im-Breisgau. In 1939, after several trips to Italy, Bissier moved to Hagnau, Germany, on the shores of Lake Constance; there he started to make designs for tapestries and fabrics. He executed his first color monotypes in 1947 and in the early fifties began to experiment with egg-tempera, which he used in his "miniatures" of 1955-56. His friendship with Jean Arp dated from 1957. In 1958 the first major Bissier retrospective was held at the Kestner-Gesellschaft Hannover and traveled to other German cities. The artist executed a mural for the University in Freiburg-im-Breisgau in 1959-60. He was honored with one-man exhibitions at the Venice Biennale in 1960 and the São Paulo Bienal the following year. He became friends with Nicholson and Mark Tobey in this period. In 1961 Bissier moved to Ascona, Switzerland, where he died on June 18, 1965.

ALBERTO BURRI b. 1915

Alberto Burri was born in Città di Castello, northern Umbria, on March 12, 1915. He received his medical degree from the University in Perugia in 1940 and practiced as a physician with the Italian Army in North Africa during World War II. In 1943 Burri was captured by the British, and the following year he was imprisoned by the Americans in Hereford, Texas. It was there that he began to paint.

Shortly after his repatriation, Burri moved to Rome. Although his earliest canvases were still lifes and landscapes, he soon started to paint abstract oils. His first one-man exhibition took place at the Galleria La Margherita in Rome in 1947. Burri visited Paris for the first time in 1949 and the following year he became a member of the *Origine* group in Rome. By 1949-50 he began to work with burlap; burlap and fabric collages continued to occupy him until 1960. Concurrent with these burlap *sacchi* (sacks) he experimented with *muffe* (molds) and *gobbi* (hunchbacks). His work was exhibited for the first time in the United States in a one-man show at the Frumkin Gallery in Chicago in 1953. In 1955 Burri began burning his media and the *combustione* resulted. Both the *legni* (wood pieces) and *ferri* (iron pieces) employ aspects of the *combustione* process.

An important Burri exhibition was held at the Carnegie Institute in Pittsburgh in 1957 and subsequently circulated in the United States. He was awarded the UNESCO Prize at the São Paulo Bienal of 1959 and was honored with a one-man exhibition at the Venice Biennale the following year. In 1965 he won the Grand Prize at the São Paulo Bienal. Burri's use of unconventional and common materials continued into the sixties and seventies with the *plastiche* (plastics); the white plastics; the *cretti* (cracks) and the works in cellotex. He has designed decor for ballets at La Scala in Milan (1963) and the opera in Rome (1972) and for other performances. A retrospective that traveled in 1977-78 to museums in the United States including the Guggenheim was his first major show in this country in more than a decade. Burri currently resides in Città di Castello.

JEAN DUBUFFET b. 1901

Jean Dubuffet was born in Le Havre on July 31, 1901. He attended art classes in his youth and in 1918 moved to Paris to study at the Académie Julian, which he left after six months. During this time Dubuffet met Suzanne Valadon, Raoul Dufy, Fernand Léger and Max Jacob and became fascinated with Hans Prinzhorn's book on psychopathic art. He traveled to Italy in 1923 and South America in 1924. Then Dubuffet gave up painting for about ten years, working as an industrial draftsman and later in the family wine business. He committed himself to becoming an artist in 1942.

Dubuffet's first one-man exhibition was held at the Galerie René Drouin in Paris in 1944. During the forties the artist associated with Charles Ratton, Jean Paulhan, Georges Limbour and André Breton. His style and subject matter in this period owed a debt to Paul Klee. From 1945 he

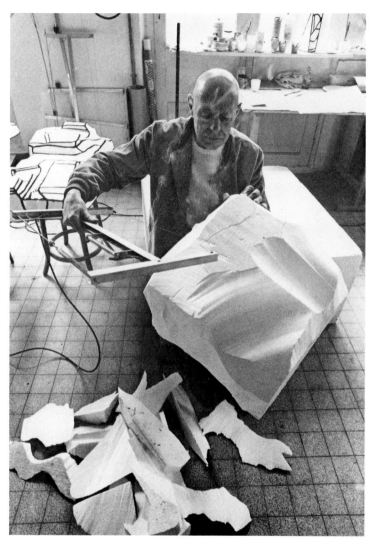

Dubuffet, Paris, 1970

collected *Art Brut*, spontaneous, direct works by untutored individuals, such as mental patients. The Pierre Matisse Gallery gave him his first one-man show in New York in 1947.

From 1951 to 1952 Dubuffet lived in New York; he then returned to Paris, where a retrospective of his work took place at the Cercle Volney in 1954. His first museum retrospective occurred in 1957 at the Schloss Morsbroich, Leverkusen, Germany. Major Dubuffet exhibitions have since been held at the Musée des Arts Décoratifs, Paris, The Museum of Modern Art, New York, The Art Institute of Chicago, the Stedelijk Museum, Amsterdam, the Tate Gallery, London, and The Solomon R. Guggenheim Museum, New York. His paintings of *L'Hourloupe*, a series begun in 1962, were exhibited at the Palazzo Grassi in Venice in 1964. A collection of Dubuffet's writings, *Prospectus et tous écrits suivants*, was published in 1967, the same year he started his architectural structures. Soon thereafter he began numerous commissions for monumental outdoor sculptures. In 1971 he produced his first theater props, the *"practicables."* A major Dubuffet retrospective was presented at the Akademie der Künste, Berlin, the Museum Moderner Kunst, Vienna, and the Joseph-Haubrichkunsthalle, Cologne, in 1980-81. In 1981 The Solomon R. Guggenheim Museum, New York, observed the artist's eightieth birthday with an exhibition. Dubuffet lives and works in Paris and Périgny.

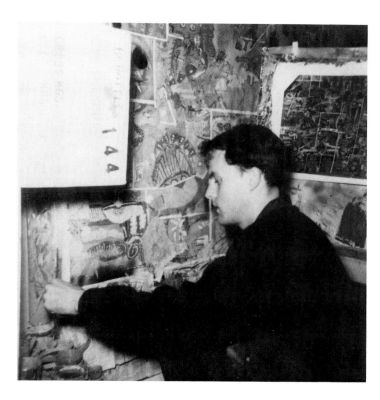

Fahlström, 1962

ÖYVIND FAHLSTRÖM 1928-1976

Öyvind Axel Christian Fahlström was born on December 28, 1928, of Scandinavian parents, in São Paulo, Brazil. In 1939 he returned to Sweden for a visit, but was forced to remain because of the outbreak of war. He became a Swedish citizen in 1947. From 1949 to 1952 Fahlström studied art history and archaeology at the University of Stockholm. He worked as a theater critic and journalist in Stockholm from 1950 to 1955; during this period he spent time in Rome and Paris. Fahlström's first one-man exhibition took place in Florence at Galleria Numero in 1953. In 1954 Fahlström began to devote most of his energies to painting, although he continued to write. By 1957 Fahlström evolved his characteristic comic-strip idiom, in which he commented on contemporary politics and society. In 1959 he received the Painting Prize at the São Paulo Bienal. He participated in the Carnegie International in Pittsburgh in 1960.

The following year the artist received an award for study in the United States and moved from Stockholm to New York. Here Fahlström became friendly with Claes Oldenburg, Jasper Johns and Robert Rauschenberg. He began to make films in 1961. In 1962 he made his first Variable Painting, in which the spectator can arrange magnetized painted elements on a metal sheet in various ways. From 1962 to 1966 he staged Happenings and sound events in Stockholm and New York. Fahlström further exploited the role of chance in the Game series, an elaboration of the Variable Paintings, begun in 1965. In 1966 he participated in the Venice Biennale and completed his Variable Multiples and his first work with oil on photographs. The Sidney Janis Gallery in New York presented many one-man exhibitions of his work from 1967 through 1976. Fahlström was given a retrospective in the PENTACLE exhibition at Musée des Arts Décoratifs in Paris in 1967, participated in *4. Documenta* in Kassel in 1968 and showed small works at The Museum of Modern Art in New York in 1969. During this period he wrote articles and plays for stage and screen. Fahlström died on November 9, 1976, in Stockholm. The Moderna Museet, Stockholm, and the Centre Georges Pompidou, Paris, mounted a major Fahlström retrospective in 1979-80. Fahlström's first major museum exhibition in the United States took place at The Solomon R. Guggenheim Museum in New York in 1982 and traveled to the Walker Art Center in Minneapolis in 1983.

LUCIO FONTANA 1899-1968

Lucio Fontana was born on February 19, 1899, in Rosario de Santa Fé, Argentina, of a Milanese father and an Argentinian mother. He lived in Milan from 1905 to 1922, when he went back to Argentina. In 1926 he participated in the Salon Nexus in Rosario de Santa Fé and the following year won a local monument competition. On returning to Italy in 1928 Fontana entered the Accademia di Belle Arti di Brera in Milan, which he attended for two years. His first one-man show opened in Milan in 1930 at the Galleria del Milione; in 1934 he joined a group of Italian abstract sculptors associated with this gallery. During these years Fontana executed several commissions for tombs. In 1935 he settled in Paris, where he joined the *Abstraction-Création* group and began working as a ceramicist. Two years later one-man exhibitions of Fontana's ceramics were held at the Galleria del Milione and the Galerie Jeanne Bucher-Myrbor in Paris. About this time he met Joan Miró, Brancusi and Tristan Tzara in Paris.

Fontana moved back to Argentina in 1940 and worked on sculptures for a monument to The Flag. He won First Prize for Sculpture in 1942 at the Salón Nacional de Bellas Artes de Buenos Aires. In 1946 Fontana cofounded the Academia de Altamira and with a group of his students published the *Manifiesto Blanco.* He resettled in Milan in 1947 and resumed his work in ceramics. In 1949 he created an *ambiente spaziale* (spatial environment) at the Galleria del Naviglio in Milan. Beginning in the 1940s Fontana made space the subject of his work. From that time he used the title *Concetto Spaziale* for many of his works and his imagery took many forms, including "holes" and "cuts."

During the 1950s Fontana was given numerous one-man shows in Milan, and he worked on several projects with the architect Luciano Baldessari. He participated in the *Monochrome Malerei* exhibition at the Städtisches Museum in Leverkusen and a solo exhibition of his work took place at the Galerie Schmela in Düsseldorf in 1960. The following year the artist visited New York on the occasion of his one-man show at the Martha Jackson Gallery. He presented an *ambiente spaziale* at his retrospective at the Walker Art Center in Minneapolis in 1966. That same year Fontana produced costume and set designs for La Scala in Milan. A number of one-man exhibitions of his work were held in Europe in 1967. Fontana died on September 7, 1968, in Commabio, Italy.

RICHARD HAMILTON b. 1922

Richard Hamilton was born on February 24, 1922, in London. His schooling took place entirely in London. While working in advertising in 1936, he attended classes at Westminster Technical College and St. Martin's School of Art. From 1938 to 1940 and again in 1946 Hamilton studied painting at the Royal Academy Schools. After his expulsion he served in the army until 1948, when he entered the Slade School of Fine Art. He devised and designed the 1951 exhibition *Growth and Form* at the Institute of Contemporary Art (I.C.A.) in London.

In 1952 Hamilton began teaching at the Central School of Arts and Crafts in London and joined the *Independent Group* at I.C.A. with Lawrence Alloway, John McHale, Eduardo Paolozzi and others. From 1953 to 1966 he taught at King's College, University of Durham, which was to become the University of Newcastle-upon-Tyne. The show *Man, Machine and Motion* was organized by Hamilton and presented at the Hatton Gallery, Newcastle-upon-Tyne, and I.C.A. in 1955. He collaborated with McHale and John Voelcker on an environment for the *This is Tomorrow* exhibition of 1956 at the Whitechapel Gallery in London. In his complex oeuvre, Hamilton combines various media as well as imagery from disparate sources. The resulting works raise questions about the traditional intellectual and aesthetic boundaries of art.

In 1960 Hamilton received the William and Noma Copley Foundation award for painting and produced his typographic reproduction of Duchamp's *Green Box.* His 1963 visit to the United States familiarized him with the work of the American Pop artists. He continued his homage to Duchamp, reconstructing the *Large Glass* in 1965-66 and organizing the show *The Almost Com-*

plete Works of Marcel Duchamp at the Tate Gallery in London the following year. In 1967 Hamilton's graphics were exhibited at the Galerie Ricke in Kassel and his paintings at the Alexandre Iolas Gallery in New York. He was given one-man shows in 1969 at the Robert Fraser Gallery in London, the Galerie Hans Neuendorf, Hamburg, and Studio Marconi in Milan. One-man exhibitions of his work were presented by the National Gallery of Canada, Ottawa, in 1970, the Stedelijk Museum in Amsterdam in 1971 and The Solomon R. Guggenheim Museum, New York, in 1973. Hamilton lives near London.

DAVID HOCKNEY b. 1937

David Hockney was born on July 9, 1937, in Bradford, England. From 1953 to 1957 he studied at the Bradford College of Art. After graduating, Hockney, a conscientious objector, worked for two years in hospitals in Bradford and Hastings in lieu of military service. In 1959 he enrolled at the Royal College of Art in London; this year he met Kitaj and Hamilton and began to experiment with etching, aquatint and watercolor. For a brief period Hockney painted flat, primitive figures, recalling the work of William Turnbull and Barbara Hepworth; these were succeeded by paintings on literary, political or allegorical themes. In 1960 he participated in his first group shows at the RBA Galleries in London. Hockney graduated in 1962 with a Gold Medal.

Hockney's first one-man exhibition was held at the Kasmin Gallery in London in 1963. He was awarded the Graphics Prize at the Paris Biennale the same year. In 1964 The Museum of Modern Art in New York honored Hockney with an exhibition of his series of etchings and aquatints, *A Rake's Progress*, 1961-63, an account of his first trip to New York in 1961. Hockney's move to Los Angeles in 1964 marked a new stylistic direction: he began to execute still lifes, interiors and landscapes in bright, unmodulated acrylics, applied with a roller to unprimed canvas. During the 1960s he taught at universities in the United States. Hockney participated in the São Paulo Bienal and *4. Documenta* in Kassel in 1967 and the Venice Biennale in 1968. A major retrospective of his work was held at the Whitechapel Gallery, London, in 1970 and subsequently traveled to Hannover, Rotterdam and Belgrade. The Musée des Arts Décoratifs in Paris presented a Hockney retrospective in 1974. From 1973 to 1975 the artist lived in Paris, where he worked once more in oils, now employed in a Pointillist manner.

Hockney designed costumes and sets for *Ubu Roi* at the Royal Court Theater, London (1966), and *Parade* at the Metropolitan Opera, New York (1980). His autobiography, *David Hockney*, was published in 1976. The artist has long collected photographs, which he uses as compositional aids; his most recent works are montages of Polaroid prints. Hockney travels extensively and lives and works in California.

ASGER JORN 1914-1973

Asger Jorn was born Asger Oluf Jørgensen in Vejrum, Jutland, Denmark, on March 3, 1914. In the autumn of 1936 he visited Paris, where he studied at Léger's Académie Contemporaine. During the war Jorn remained in Denmark, painting canvases that reflect the influence of Ensor, Kandinsky, Klee and Miró and contributing to the magazine *Helhesten*.

Jorn traveled to Swedish Lapland in the summer of 1946, met Constant in Paris that autumn and spent six months in Djerba, Tunisia, in 1947-48. His first one-man exhibition in Paris took place in 1948 at the Galerie Breteau. At about the same time the COBRA (an acronym for Copenhagen, Brussels, Amsterdam) movement was founded by Appel, Constant, Corneille, Christian Dotremont, Jorn and Joseph Noiret. The group's unifying doctrine was complete freedom of expression with emphasis on color and brushwork. Jorn edited monographs of the Bibliothèque Cobra before disassociating himself from the movement.

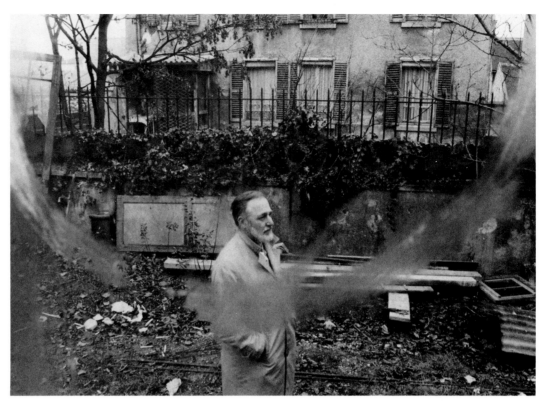

Jorn, 1968

In 1951 Jorn returned, poor and ill, to Silkeborg, his hometown in Denmark. He began his intensive work in ceramics in 1953. The following year he settled in Albisola, Italy, and participated in a continuation of COBRA called *Mouvement International pour un Bauhaus Imaginiste.* Jorn's activities included painting, collage, book illustration, prints, drawings, ceramics, tapestries, commissions for murals and, in his last years, sculpture. He participated in the *Situationist International* movement from 1957 to 1961 and worked on a study of early Scandinavian art between 1961 and 1965. After the mid-1950s Jorn divided his time between Paris and Albisola. His first one-man show in New York took place in 1962 at the Lefebre Gallery. From 1966 Jorn concentrated on oil painting and traveled frequently, visiting Cuba, England and Scotland, the United States and the Orient. Jorn died on May 1, 1973, in Aarhus, Denmark. A major posthumous retrospective of his work occurred at The Solomon R. Guggenheim Museum, New York, in 1982 and traveled to the Barbican Center for Arts and Conferences, London, in 1983.

R.B. KITAJ b. 1932

Ron Kitaj was born on October 29, 1932, in Cleveland. As a child he attended drawing classes at the Cleveland Museum of Art; in 1943 he moved with his family to Troy, New York. In 1950 Kitaj worked on a cargo ship and also studied at Cooper Union in New York. He traveled in Europe for the first time from 1951 to 1953, studying at the Akademie der Bildenden Künste in Vienna. A visit to New York, journeys in South America as a sailor and travels in Europe and North Africa followed. From 1955 to 1957 he served as an illustrator in the United States Army, stationed at Fountainbleau.

Kitaj studied at the Ruskin School of Fine Arts in Oxford, England, under the G.I. Bill from 1957 to 1959. In 1958 he participated in his first group exhibition at the RBA Galleries, London. From 1960 to 1962 Kitaj attended the Royal College of Art in London. During this period he worked in collage and became friendly with Hockney and the poet Jonathan Williams. In 1962 Kitaj collaborated briefly with Paolozzi and met Chris Prater, a silk-screen printer with whom he worked for the next decade on a series of collage prints. This year he also met Bacon. Kitaj taught at art schools in England from 1961 to 1967. During the 1960s he used printed images from popular sources in his work. The artist's first one-man exhibition was held in 1963 at Marlborough New London Gallery, London. In 1964 he was included in the *Guggenheim International Award* exhibition in New York, the Venice Biennale and *Documenta III* in Kassel. His first one-man exhibition in New York took place at the Marlborough-Gerson Gallery in 1965 and his first solo museum exhibition followed the next year at the Los Angeles County Museum of Art. In the mid-sixties Kitaj formed friendships with the poet Robert Duncan and the painter Jesse Collins. He collaborated with the poet Robert Creely on *A SIGHT*, published in 1967, and *A Day Book*, published in 1970.

He was a visiting professor at the University of California at Los Angeles in 1970. During the 1970s the artist focused increasingly on the human figure in his work. In 1975, inspired by an exhibition of Degas pastels, Kitaj began to make life drawings in pastel. In 1981 The Hirshhorn Museum and Sculpture Garden, Smithsonian Institution, Washington, D.C., presented a major retrospective of his work that traveled to the Cleveland Museum of Art. Kitaj lives in London.

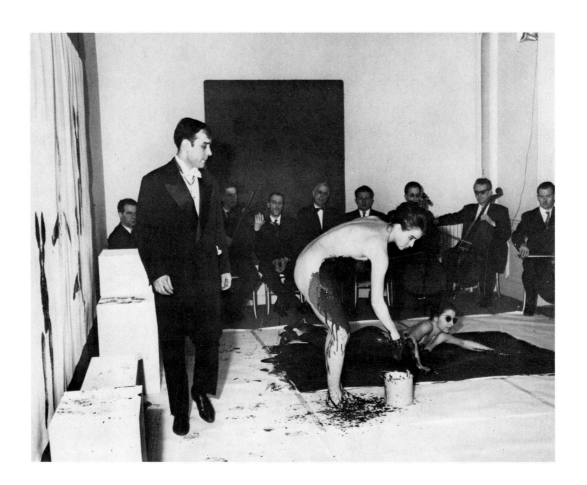

Klein at performance of his *Anthropometries of the Blue Period*, at Galerie Internationale d'Art Contemporain, Paris, March 9, 1960

YVES KLEIN 1928-1962

Yves Klein was born on April 28, 1928, in Nice. From 1944 to 1946 he studied at the Ecole Nationale de la Marine Marchande and the Ecole Nationale des Langues Orientales and began practicing judo. At this time he became friendly with Claude Pascal and Arman Fernandez and started to paint. Klein composed his first "Symphonie monoton" in 1947. During the years 1948 to 1952 he traveled to Italy, Great Britain, Spain and Japan. In 1955 Klein settled permanently in Paris, where he was given a one-man show at the Club des Solitaires. His monochrome paintings were shown at the Galerie Colette Allendy in Paris in 1956.

The artist entered his blue period in 1957; this year a double exhibition of his work was held at the Galerie Iris Clert and the Galerie Colette Allendy in Paris. In 1958 he began using nude models as "living paintbrushes" and producing sponge reliefs and mounting individual sponges on stone pedestals. Also in that year he undertook a project for the decoration of the entrance hall of the new opera house in Gelsenkirchen, Germany. The first manifesto of the group *Nouveaux Réalistes* was written in 1960 by Pierre Restany and signed by Klein, Arman, Daniel Spoerri, Jean Tinguely and others. In 1961 Klein was given a retrospective at the Museum Haus Lange in Krefeld, and his first one-man show in the United States at the Leo Castelli Gallery in New York. He and the architect Claude Parent collaborated that year on the design for fountains of water and fire, *Les Fontaines de Varsovie,* for the Palais de Chaillot in Paris. In 1962 Klein executed a plaster cast of Arman and took part in the exhibition *Antagonismes 2: l'objet* at the Musée des Arts Décoratifs in Paris. Shortly before his death he appeared in the film *Mondo Cane.* Klein died suddenly on June 6, 1962, at age thirty-four, in Paris. A major retrospective of his work was organized by the Institute for the Arts, Rice University, Houston, in 1982 and traveled to the Museum of Contemporary Art, Chicago, The Solomon R. Guggenheim Museum, New York, and the Musée National d'Art Moderne, Centre Georges Pompidou, Paris, in 1983.

JIŘÍ KOLÁŘ b. 1914

Jiří Kolář was born on September 24, 1914, in Protivín in southern Bohemia. As a young man he learned carpentry and worked at a variety of odd jobs. He was interested in literature and decided to become a poet after reading Marinetti's *Les Mots en liberté futuristes* in Czech translation in 1930. In 1934 Kolář began to experiment with collage; some of these early works were exhibited in 1937 at the Mozarteum in Prague.

It was as a poet that Kolář initially distinguished himself. His first volume of poetry, *Křestný list (Birth Certificate),* was published in 1942. The following year he was a founding member of *Group 42,* comprised of Czech artists, photographers and art historians interested in the role of modern urban society in their work. After the war years Kolář moved to Prague, became an editor of the weekly *Lidová kultůra (Popular Culture)* and continued to write poetry. His poems were published in several books including *Dny v roce (Days in a Year)* of 1948. His first trip outside Czechoslovakia took him to England and Scotland. In the early 1950s Kolář experimented with various collage techniques. In 1953 he was imprisoned for several months because his poetry was regarded as anti-Stalinist; he was forbidden to publish until 1964. He worked primarily on concrete poems and collages where unrelated texts and images are juxtaposed. An important one-man show was held in 1962 at the Galerie S.V.U. Mánes in Prague; he has subsequently exhibited frequently in Europe. The forms of his art multiplied with crazygrammes, rollages, chiasmages, crumplages, banners and veiled intercollages. In 1967 Kolář began making daily collages, an outgrowth of the daily journal he had kept since 1946. He received First Prize at the São Paulo Bienal in 1969 and the following year traveled to the United States, Canada and Japan. Major exhibitions of his work were organized by The Solomon R. Guggenheim Museum, New York, in 1975 and the Albright-Knox Art Gallery in Buffalo in 1978. The artist moved from Prague to Paris in 1983.

ALBERTO MAGNELLI 1888-1971

Alberto Magnelli was born in Florence on July 1, 1888. Essentially a self-taught painter, he made his artistic debut at the Venice Biennale in 1910. In 1911 Magnelli became friendly with the Futurist artists Filippo Tommaso Marinetti, Umberto Boccioni, Carlo Carrà and the poet Aldo Palazzeschi, though he did not collaborate with them. His early style already demonstrated a tendency towards simplified, solid geometric form and was essentially abstract. In 1914 Magnelli visited Paris, where he met with Guillaume Apollinaire, Pablo Picasso, Léger and Max Jacob. During the next few years Magnelli investigated the possibilities of both representation and abstraction. His experiments with abstraction culminated in the Lyrical Explosion works of 1918, which are dominated by dynamic arabesques rhythmically disposed across the canvas. The Galleria Materassi in Florence gave Magnelli his first one-man show in 1921. By 1922 he was executing paintings that show the influence of the Scuola Metafisica: formalized landscapes in cool sober colors. Inspired by huge blocks of marble he saw in the quarries of Carrara in 1931, Magnelli painted his near-abstract Stone series. Shortly thereafter he renounced figuration definitively and arrived at his completely abstract style. Magnelli moved from Florence to Paris in 1931. His first one-man show in Paris took place at the Galerie Pierre Loeb in 1934. In 1937 the Nierendorf Gallery presented his first one-man show in New York.

During World War II Magnelli fled to the outskirts of Grasse, where he associated with Arp, Sophie Taeuber-Arp and Sonia Delaunay. In 1944 he returned to Paris. Magnelli subsequently was honored with numerous retrospectives, among them presentations at the Venice Biennale, 1950; Palais des Beaux-Arts, Brussels, 1954; Museum Folkwang Essen, 1964; and Musée d'Art Moderne de la Ville de Paris, 1973. He received the First Grand Prize for Foreign Painting at the São Paulo Bienal in 1955 and the Guggenheim International Award for Italy in 1958. From 1959 Magnelli divided his time between Meudon and Paris. The artist died in Meudon on April 20, 1971.

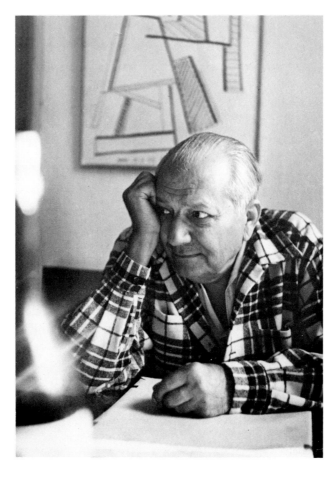

Magnelli

MATTA b. 1911

Roberto Sebastian Antonio Matta Echaurren was born on November 11, 1911, in Santiago, Chile. After studying architecture at the Universidad Católica in Santiago, Matta went to Paris in 1934 to work as an apprentice to the architect Le Corbusier. By the mid-thirties he knew the poet Federico García Lorca, Salvador Dalí and André Breton; in 1937 he left Le Corbusier's atelier and joined the Surrealist movement. This same year Matta's drawings were included in the Surrealist exhibition at Galerie Wildenstein in Paris. In 1938 he began painting with oils, executing a series of fantastic landscapes, which he called "inscapes" or "psychic morphologies."

Matta fled Europe for New York in 1939, where he associated with other Surrealist emigrés including Max Ernst, Yves Tanguy, André Masson and Breton. The Julien Levy Gallery in New York presented his first one-man show of paintings in 1940, and he was included in the *Artists in Exile* exhibition at the Pierre Matisse Gallery in New York in 1942. During the forties Matta's painting anticipated many innovations of the Abstract Expressionists and influenced artists such as Arshile Gorky and Robert Motherwell. Towards the end of the war he evolved increasingly monstrous imagery; the appearance of mechanical forms and cinematic effects in Matta's work reflects the influence of Marcel Duchamp, whom he met in 1944. He broke with the Surrealists in 1948 and returned to Europe, settling in Rome in 1953. A mural for the UNESCO Building in Paris was executed by the artist in 1956.

In 1957 The Museum of Modern Art in New York gave him a major retrospective, which traveled to the Institute of Contemporary Art in Boston and the Walker Art Center in Minneapolis. His work was exhibited at the São Paulo Bienal in 1962, in Berlin in 1970 and Hannover in 1974. The artist now lives in Tarquinia, Italy, and in Paris.

HENRI MICHAUX b. 1899

Henri Michaux was born on May 24, 1899, in Namur, Belgium. His early childhood was spent in Brussels and his adolescence in a country boarding school where he majored in Flemish studies. In 1914 Michaux returned to German-occupied Brussels, and during this period he began to write. His writings were first published in 1922, and Michaux had already gained recognition as an author when he moved to Paris in 1924. In Paris Michaux saw the work of Max Ernst, Giorgio de Chirico and Klee. Between 1925 and 1927 he began to draw and paint in his spare time, although he had no formal artistic training. In 1927 Michaux traveled to Ecuador with his poet friend Alfredo Gangoténa, and this same year his first important book, *Qui je fus,* was published in Paris.

For the next ten years Michaux traveled extensively, visiting Turkey, South America, India and China, and wrote numerous books about his journeys. In 1937 he began to paint on a regular basis and was given his first exhibition at the Galerie Pierre, Paris. The artist for the most part uses India ink but has also worked in other media such as oil and pastel. His series include the Alphabets, 1924 to 1934; Black Backgrounds, 1937-38; Frottages, 1944 to 1947; and Movements, 1950-51. In 1954 Michaux began to experiment with hallucinogens and from this time until 1962 he attempted to depict his drug-induced visions. Michaux has also given written accounts of these experiences in books such as *Misérable Miracle* of 1957. In 1964 a major Michaux retrospective was held at the Musée National d'Art Moderne, Paris, and his work was the subject of the film *H.M. ou l'Espace du Dedans.* In 1966 the Galerie Le Point Cardinal, Paris, began to represent Michaux and showed his work regularly throughout the next decade. In 1978 the Musée National d'Art Moderne, Paris, held an important Michaux retrospective that traveled in part to The Solomon R. Guggenheim Museum, New York, and the Musée d'Art Contemporain, Montreal. Michaux lives in Paris.

GIORGIO MORANDI 1890-1964

Giorgio Morandi was born on July 20, 1890, in Bologna. He attended the Accademia di Belle Arti in Bologna from 1907 until 1913. Morandi's early work reveals the influence of Giotto, Uccello, Masaccio and Piero as well as Cézanne, the early Cubists and, above all, the *Macchiaoli*, nineteenth-century Italians who emphasized tonal value and contrasts of broad flat color areas in their painting. In 1914 Morandi was appointed instructor for drawing and printmaking for the elementary schools of Bologna, a position he retained for more than fifteen years. That same year he met Boccioni and Carrà and took part in his first exhibition, a one-day event in Bologna. Morandi served briefly in the military in 1915. From 1918 to 1921 he associated with de Chirico and the artists of the *Scuola Metafisica.* His metaphysical still lifes of 1918-19, in which incongruous and ambiguous objects are juxtaposed, were frequently reproduced. Morandi's first one-man exhibition was held in 1919 at the Galleria Giosi in Rome, and he was included in the *Gruppo Valori Plastici* show in Florence in 1922.

Morandi's paintings of the 1920s are indebted to Cézanne; these are still lifes of familiar domestic objects, in particular vases and bottles, themes he continued to refine throughout his career. In 1926 the artist was named Director of Elementary Schools in several communities in Reggio Emilia and Modena. From 1927 to 1932 Morandi summered in Grizzana and worked intensively in printmaking. Morandi participated in numerous Venice Biennale exhibitions from 1928 and in the Rome Quadriennale in 1931, 1935, when he was honored with a retrospective, and 1955. He was named Professor of Intaglio at the Accademia di Belle Arti in Bologna in 1930, a post he held until 1956. From 1934 to 1944 he spent long periods in Grizzana.

Morandi was appointed to the Accademia Nazionale di San Luca in Rome in 1948. A one-man exhibition of his etchings took place at the Palais des Beaux-Arts in Brussels in 1949. The jury of the São Paulo Bienal awarded him the Grand Prize for Etching in 1953 and the Grand Prize for Painting in 1957. In 1956 Morandi retired from teaching and traveled to Switzerland on the occasion of his exhibition at the Kunstmuseum in Winterthur; this was his only trip outside of Italy. From 1958 he divided his time between Grizzana and Bologna. Morandi was awarded the Gold Medal, an ancient honor of the University of Bologna, in 1963. The artist died in Bologna on June 18, 1964. His important posthumous retrospectives include an exhibition organized by the Des Moines Art Center in 1981 that traveled to the San Francisco Museum of Modern Art and The Solomon R. Guggenheim Museum, New York.

BEN NICHOLSON 1894-1982

Ben Nicholson was born on April 10, 1894, in Denham, Buckinghamshire, England. Both his parents were painters. Nicholson attended the Slade School of Fine Art in London in 1910-11; between 1911 and 1914 he traveled in France, Italy and Spain. He lived briefly in Pasadena in 1917-18. His first one-man show was held at the Adelphi Gallery in London in 1922. Shortly thereafter he began abstract paintings influenced by Synthetic Cubism. By 1927 he had initiated a primitive style inspired by Rousseau and early English folk art.

From 1931 Nicholson lived in London; his association with Moore and Barbara Hepworth dates from this period. In 1932 he and Hepworth visited Brancusi, Arp, Braque and Picasso in France. Herbin and Hélion encouraged them to join *Abstraction-Création* in 1933. Nicholson made his first wood relief in 1933; the following year, after meeting Mondrian, he geometricized his forms and restricted his palette to white. Hepworth and Nicholson married in 1934. In 1937 Nicholson edited *Circle: International Survey of Constructivist Art,* which he had conceived in 1935.

After moving to Cornwall in 1939, Nicholson resumed painting landscapes and added color to his abstract reliefs. In 1945-46 he turned from reliefs to linear, abstract paintings. Nicholson was commissioned to paint a mural for the Time-Life Building in London in 1952. He was honored with retrospectives at the Venice Biennale in 1954, and at the Tate Gallery, London, and the Stedelijk Museum, Amsterdam, in 1955. Nicholson moved to Ticino, Switzerland, in 1958 and

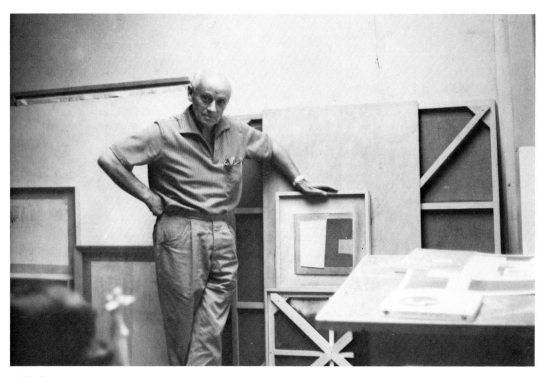

Nicholson, 1960

began to concentrate once more on painted reliefs. In 1964 he made a concrete wall relief for the *Documenta III* exhibition in Kassel and in 1968 was awarded the Order of Merit by Queen Elizabeth. The Albright-Knox Art Gallery, Buffalo, organized a retrospective of his work in 1978. Ben Nicholson died on February 6, 1982, in London.

ARNULF RAINER b. 1929

Arnulf Rainer was born on December 8, 1929, in Baden near Vienna. His first works were watercolor landscapes but he became interested in drawing the human figure while attending trade school in Villach from 1947 to 1949. In 1950 in Vienna Rainer met Ernst Fuchs, Erich Brauer, Anton Lehmden, Wolfgang Hollegha and Josef Mikl, with whom he founded *Hundsgruppe (Dog's Group)*. This group was given its first exhibition at the Institut für Kunst und Wissenschaft in Vienna in 1951. In November of the same year Rainer's first one-man show was held at the Galerie Kleinmayer in Klagenfurt, Austria. Since 1951 he has written extensively about his work. Rainer met André Breton in Paris in 1952. His early work reveals the influence of Surrealism: the automatic drawing in his Microstructures, Centralisations, Optical Decentralisations and Blind Paintings expresses unconscious impulses. Rainer's work was shown for the first time in the United States in a group exhibition at The Art Institute of Chicago in 1953.

Rainer is best known for his Overpaintings, serial works begun in 1954 in which he effaces his own paintings and those of other artists with monochrome pigment. While developing this approach, he also experimented with color relationships, shaped canvases and photographs of his face or body. In 1957 the artist destroyed much of his early production. Rainer founded the *Pintorarium,* an antiacademic organization, with Hundertwasser and Fuchs in 1959. In the same year he made his first film, *Arnulf Rainer,* with Peter Kubelka. Since then he has often explored the media of film and video.

Rainer lived in Berlin from 1963 to 1967, during which time he experimented with alcohol and LSD to induce creative states. His numerous awards include the Austrian State Prize for Graphics in 1966 and the Artist Prize from the city of Vienna in 1974 (the latter was rescinded when he refused to attend the ceremony). His first museum retrospective was held at the Museum des 20. Jahrhunderts in Vienna in 1968; important retrospectives of Rainer's work have since been mounted at the Kunstverein Hamburg (1971); Kunsthalle Bern (1977); Stedelijk van Abbemuseum, Eindhoven, and the Whitechapel Art Gallery, London (1980). In 1981 he was appointed professor at the Akademie der Bildenden Künste, Vienna. Rainer was included in *Documenta* 7 in Kassel in 1982. The artist lives and works in Vienna, Upper Austria and Bavaria.

GERHARD RICHTER b. 1932

Gerhard Richter was born in Dresden in 1932. From 1949 to 1952 he worked in advertising and as a scene painter at the Stadttheater in Zittau. He attended the Kunstakademie, Dresden, from 1953 to 1957, and then worked as a photo-laboratory technician until 1960. In 1960 Richter moved to West Germany, where he studied at the Staatliche Kunstakademie in Düsseldorf from 1961 to 1963. During these early years Richter worked in a figurative mode. Since 1962 photography has been central to his art, when he began to base his paintings on photographs. He also gave them the look of photographs by treating his subject matter objectively. His early themes in this idiom ranged from family snapshots to celebrity portraits to picturesque scenery. In 1963 Richter and Konrad Fisher-Lueg announced the birth of Capitalist Realism with an exhibition at a Düsseldorf furniture store in which they presented themselves as living sculptures. Richter's first one-man show was held the following year in Munich at Galerie Heiner Friedrich. The artist was Guest Lecturer at the Hochschule für Bildenden Künste in Hamburg in 1967 and Lecturer in Fine Arts at the Gymnasium Düsseldorf-Gerresheim in 1968-69. Richter's work was first seen in New York in 1969 in *9 Young Artists: Theodoron Awards* at The Solomon R. Guggenheim Museum.

Since the sixties, in his search for ways to transcribe reality, Richter has interpreted a wide variety of subjects in a range of techniques: expressionistically painted aerial views of towns and mountains; *Farbtafeln* (sample paint charts); cloud formations and seascapes; monochromatic gray paintings; forty-eight portraits based on encyclopedia photographs of famous men of the nineteenth and twentieth centuries; and, most recently, abstractions. Richter participated in the Venice Biennale and *Documenta 5*, Kassel, in 1972. The artist was honored with a retrospective at the Musée National d'Art Moderne, Centre Georges Pompidou, Paris, in 1976. His first one-man show in New York was held in 1978 at Sperone Westwater Fischer, where he exhibited again in 1980 and 1983. The Kunsthalle Bielefeld and Mannheimer Kunstverein exhibited his abstract paintings in 1982, the same year he took part in *Documenta 7*, Kassel. Since 1971 Richter has lived in Düsseldorf, where he is Professor at the Staatliche Kunstakademie.

RICHARD SMITH b. 1931

Richard Smith was born on October 27, 1931, in Letchworth, England. He studied art at the Luton School, Luton, from 1948 until 1950, when he was inducted into the Royal Air Force. After two years of service in Hong Kong, he returned to England to study at the St. Albans School of Art from 1952 to 1954 and at the Royal College of Art in London from 1954 to 1957. In 1957 Smith was awarded a scholarship from the Royal College for travel in Italy. In the late 1950s the artist experimented with Abstract Expressionism. He taught mural decoration at Hammersmith College of Art in London from 1957 to 1958.

Smith was awarded the Harkness Fellowship of the Commonwealth Fund for travel in the United States in 1959. He settled in New York that year and was given his first one-man show there at the Green Gallery in 1961. In the 1960s he explored images drawn from popular culture,

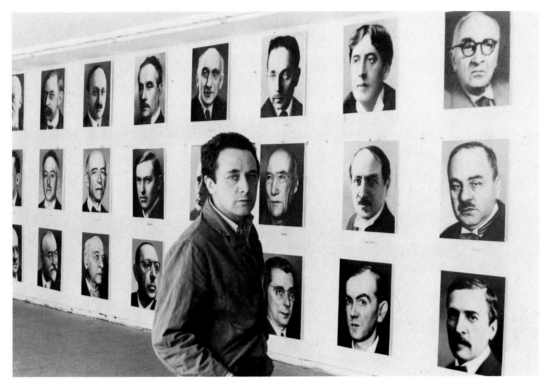

Richter with his *48 Portraits*, 1971

exploiting their formal properties rather than their associative connotations. Smith returned to England in 1961 and taught at St. Martin's School of Art in London until 1963. From 1963 to 1965 Smith lived once more in New York. A major one-man show of his work was held at the Whitechapel Art Gallery in London in 1966. He received the Mr. and Mrs. Robert C. Scull Award at the Venice Biennale of 1966 and the Grand Prize at the São Paulo Bienal of 1967. He taught at the University of Virginia, Charlottesville, in 1967 and the University of California at Irvine in 1968. In the late 1960s Smith began making abstract canvases that mediate between the flat space of painting and the three-dimensional space of sculpture. The artist returned to England in 1968, moving first to London and then to a farm in Tytherton, Wiltshire.

In the Kite paintings, begun in 1972, canvas divorced from its stretcher either hangs from the wall on strings or ribbons, or is stretched on rods or suspended from the ceiling. In 1972 Smith was decorated as Commander in the Order of the British Empire. He was given a retrospective at the Tate Gallery, London, in 1975, the same year he taught at the University of California, Davis. In 1978 the artist resettled in New York, where he currently resides.

NICOLAS DE STAËL 1914-1955

Nicolas de Staël was born on January 5, 1914, in Petrograd. The family fled the revolution to Poland when he was four. In 1922 he moved to Brussels, where he attended primary and secondary school and from 1933 to 1935 studied at the Académie Royale des Beaux-Arts. Between 1932 and 1936 de Staël traveled extensively in The Netherlands, France, Spain, Italy and Morocco. In 1938 he studied with Léger at the Académie Libre in Paris but, with the outbreak of World War II, joined the French Foreign Legion in Tunisia in 1939.

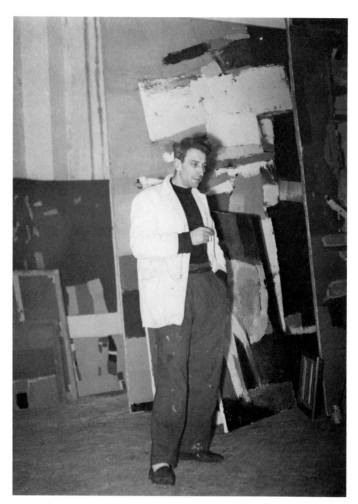

De Staël in his studio, Paris, 1952

In 1941 he moved to Nice where he met Magnelli, Arp, Marie Raymond, Le Corbusier and Robert and Sonia Delaunay. In 1942 de Staël began his first nonfigurative works, canvases with thick impasto applied with a palette knife, saturated colors and abstract forms rooted in nature. In 1943 the artist resettled in Paris, where he became friendly with Braque. He took part in a group exhibition at Galerie l'Esquisse in Paris in 1944; later that year his first one-man exhibition occurred at the same gallery. He participated in the Salon d'Automne of 1944, 1946, 1951 and 1952. De Staël became a naturalized French citizen in 1948. His work of the late forties is characterized by large forms with well-defined edges, a highly tactile paint surface and a strong sense of weight and mass. In 1950 the artist was given his first one-man show in New York, at the Theodore Schempp Gallery. From 1950 the Galerie Jacques Dubourg in Paris frequently presented one-man exhibitions of his work. From 1952 his canvases became increasingly figurative; a series of soccer players begun this year, in which the dynamic interplay of forms suggests the drama of the game, represents the culmination of this stylistic development. In 1954 the artist moved to Antibes; de Staël took his own life there on March 16, 1955. The first important retrospective of his work was held at the Musée National d'Art Moderne in Paris in 1956 and traveled to the Whitechapel Art Gallery in London. In 1965-66 a major posthumous retrospective circulated from the Museum Boymans van Beuningen, Rotterdam, to the Kunsthaus Zürich and museums in the United States including the Guggenheim.

RUFINO TAMAYO b. 1899

Rufino Tamayo was born August 26, 1899, in Oaxaca, Mexico. Orphaned by 1911, he moved to Mexico City to live with an aunt who sent him to commercial school. Tamayo began taking drawing lessons in 1915 and by 1917 had left commercial school to devote himself entirely to the study of art. In 1921 he was appointed head of the Department of Ethnographic Drawing at the Museo Nacional de Arqueología, Mexico City, where his duties included drawing pre-Columbian objects in the museum's collection. Tamayo integrated the forms and slatey tones of pre-Columbian ceramics into his early still lifes and portraits of Mexican men and women.

The first exhibition of Tamayo's work in the United States was held at the Weyhe Gallery, New York, in 1926. The first of his many mural commissions was given to him by the Escuela Nacional de Música in Mexico City in 1932. In 1936 the artist moved to New York, and throughout the late thirties and early forties the Valentine Gallery, New York, gave him shows. He taught for nine years, beginning in 1938, at the Dalton School in New York. In 1948 Tamayo's first retrospective took place at the Instituto de Bellas Artes, Mexico City. Tamayo was influenced by European modernism during his stay in New York and when he traveled in Europe in 1957. He combines his pre-Columbian heritage with the innovations of the twentieth-century European painting tradition. In 1957 he settled in Paris, where he executed a mural for the UNESCO Building in 1958. Tamayo returned to Mexico City in 1964, making it his permanent home. The French government named him Chevalier and Officier de la Légion d'Honneur in 1956 and 1969 respectively, and he has been the recipient of numerous other honors and awards. His work has been exhibited internationally in group and one-man shows. Important Tamayo retrospectives took place at the São Paulo Bienal in 1977 and The Solomon R. Guggenheim Museum, New York, in 1979. The artist lives and works in Mexico City.

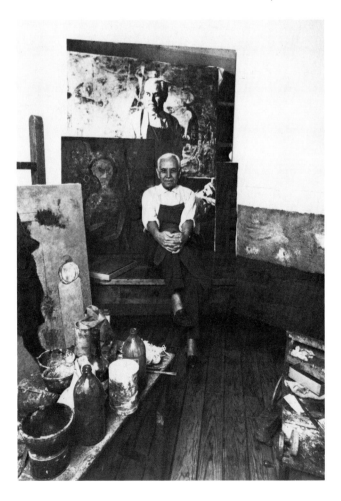

Tamayo

ANTONI TÀPIES b. 1923

Antoni Tàpies was born in Barcelona on December 13, 1923. His adolescence was disrupted by the Spanish Civil War and a serious illness of two-years duration. He was essentially self-taught as a painter; the few art classes he attended left little impression on him. Tàpies abandoned the study of law in 1946 to devote himself exclusively to art. Shortly after making this decision he began attending clandestine meetings of the *Blaus,* an iconoclastic group of Catalan artists and writers who produced the review *Dau al Set (Seven-faced Dice).*

Tàpies's work was exhibited for the first time in the controversial Saló d'Octubre of Barcelona in 1948, the year he met Miró. The influence of Miró, Klee, Ernst and Oriental philosophy is evident in his work of this period. His first one-man show was held at the Galeries Laietanes, Barcelona, in 1950. That same year the French government awarded Tàpies a scholarship that enabled him to spend a year in Paris, and he participated in the Carnegie International in Pittsburgh. He was given his first one-man show in New York in 1953 by Martha Jackson, who arranged for his work to be shown the following year in various parts of this country. Since then Tàpies has exhibited in major museums and galleries of the United States, Europe, Japan and South America. Through his somber canvases in which wall-like surfaces are built up with paint, sand and powdered marble, Tàpies has become known as a leading exponent of matter painting.

In 1966 he and other Spanish intellectuals were fined and briefly imprisoned for attending an unauthorized student meeting in Barcelona; at this time he began his collection of writings *La practica de l'art.* In 1969 he and the poet Joan Brossa published their book *Frègoli;* a second collaborative effort, *Nocturn Matinal,* appeared the following year. Tàpies received the Rubens Prize of Siegen, Germany, in 1972. Among his recent important exhibitions were retrospectives at the Musée National d'Art Moderne in Paris in 1973, the Albright-Knox Art Gallery of Buffalo in 1977 and the Venice Biennale in 1982. He now lives in Barcelona.

VICTOR VASARELY b. 1908

Victor Vasarely was born on April 9, 1908, in Pécs, Hungary. He began to study medicine at the University of Budapest in 1925. In 1927 he enrolled at the Poldini-Volkmann Academy of Painting in Budapest. Vasarely entered the Mühely (known as the Bauhaus of Budapest) in 1929 and studied there under Alexander Bortnyik. At this time he was introduced to Constructivism, Cubism and Suprematism. In 1930 Vasarely moved to Paris and for the next ten years supported himself as a graphic artist. In 1944 he ceased commercial work and started to exhibit at the Galerie Denise René, Paris.

Vasarely has investigated perceptual phenomena and optical effects of color in his work. His early painting falls into the Belle-Isle (1947), Gordes-Crystal (1948), Denfert (1951) and Kinetic (1955) periods. He published his *Manifeste jaune (Yellow Manifesto)* in 1955. In the mid-fifties he started to make silk-screen prints and during the early sixties began colored wood reliefs and metal sculptures. In 1965 he won the Grand Prize at the São Paulo Bienal and was named Chevalier de l'Ordre des Arts et Lettres by the French government. In 1967 Vasarely received the Carnegie International Painting Prize. The official inauguration of Vasarely's own museum at Gordes Château, Vaucluse, France, was held in 1970, the year the artist was named Chevalier de la Légion d'Honneur by the French government. The Sidney Janis and Denise René galleries in New York presented an important double exhibition of Vasarely's work in 1972. Since that time the artist has participated in many group shows and has been given numerous one-man exhibitions in Europe and the United States. A Vasarely museum is scheduled to open in Budapest in the spring of 1983. Vasarely lives and works in Paris and Gordes.

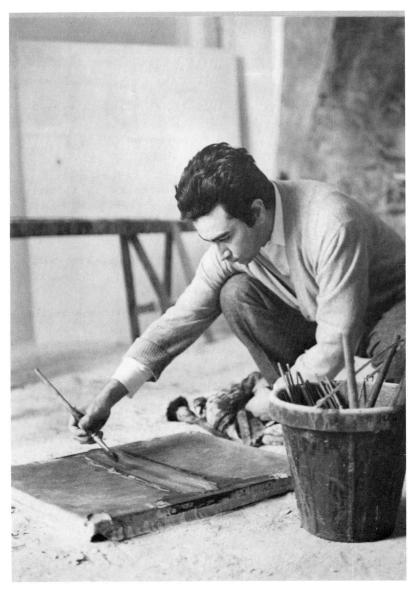

Tàpies

Photographic Credits

Works in the Exhibition

BLACK AND WHITE

Courtesy Acquavella Galleries Inc., New York: cat. no. 42

Courtesy Gallery Claude Bernard: cat. no. 23

Courtesy Castelli Feigen Corcoran, New York: cat. no. 60

F. Català-Rola, Barcelona: cat. no. 52

Carmelo Guadagno: cat. nos. 5, 6, 21, 30, 36, 39-40

Carmelo Guadagno and David Heald: cat. nos. 37, 47-49

Jacqueline Hyde, Paris: cat. no. 43

Courtesy Sidney Janis Gallery, New York: cat. no. 57

Courtesy Richard Kempe: cat. no. 58

Courtesy Susi Magnelli: cat. no. 1

Courtesy Marlborough Gallery, New York: cat. nos. 22, 32

Robert E. Mates: cat. nos. 9, 13, 18-20, 25, 27, 45, 53-54, 65

Robert E. Mates and Mary Donlon: cat. nos. 6, 12, 14, 16

Courtesy Photographic Services, The Metropolitan Museum of Art, New York: cat. no. 29

Otto E. Nelson: cat. no. 10, 34, 46

Courtesy Arnulf Rainer: cat. no. 61

Zindman/Fremont, New York: cat. no. 67

COLOR

Courtesy Thomas Ammann Fine Art, Zürich: cat. no. 24

Courtesy Gallery Claude Bernard, Inc.: cat. no. 31

Courtesy Galerie Jeanne Bucher, Paris: cat. no. 41

Courtesy Castelli Feigen Corcoran, New York: cat. no. 59

Courtesy André Emmerich Gallery Inc., New York: cat. no. 68

Carmelo Guadagno: cat. nos. 4, 7, 26, 28, 33, 38, 51

Carmelo Guadagno and David Heald: cat. nos. 3a, 3b, 63

Courtesy Mr. and Mrs. Morton L. Janklow: cat. no. 17

Courtesy Susi Magnelli: cat. no. 2

Courtesy Marlborough Gallery, New York: cat. no. 64

Robert E. Mates: cat. nos. 8, 11, 15, 44

Otto E. Nelson: cat. no. 55

Courtesy Arnulf Rainer: cat. no. 62

John Webb: cat. no. 50

Courtesy William H. Wise, Palm Springs, California: cat. no. 56

Zindman/Fremont, New York: cat. no. 66

Courtesy Galerie Rudolf Zwirner, Cologne: cat. no. 35

Supplementary Photographs

Foto Renate Bruhn, Courtesy Martha Jackson/David Andersen Gallery: p. 103

André Emmerich: p. 97

© Billy Klüver, 1962: p. 88

John Lefebre: pp. 82 (top), 85, 91

Courtesy Marlborough Gallery, London: p. 82 (bottom)

Courtesy Gerhard Richter: p. 99

Harry Shunk: p. 92

Courtesy Olga Tamayo: p. 101

Antoine Tudal, Courtesy Galerie Jeanne Bucher: p. 100

André Villers, Courtesy Susi Magnelli: p. 94

© Kurt Wyss, Basel, Switzerland: p. 87

EXHIBITION 83/2

4,000 copies of this catalogue, designed by Malcolm Grear Designers, typeset by Craftsman Type, have been printed by Eastern Press, Inc., in April 1983 for the Trustees of The Solomon R. Guggenheim Foundation.

The Tooth Fairy

igloo

One starry, moonlit night Fairyland Forest was alive with
the tinkle of tiny voices and the whisper of fluttering
wings. It was the night of the fairy gathering, when fairies
from all over the kingdom came before Queen Isabella to
voice their troubles and woes. It was a very important
occasion and everyone was there. Everyone, that is,
except for Sparkle, the tooth fairy. Sparkle was still
on her rounds, gathering the baby teeth that had fallen
out of the mouths of little girls and boys that day.
Sparkle loved little children and adored her job,
but it did mean she was always late!

A sudden hush fell over the forest, as in a glittering flash of fairy dust Queen Isabella appeared before the waiting fairies. "Are we all here?" she asked in a voice as sweet as honey and as light as a fairy's wing.

"Not quite," said one little fairy, stepping into the fairy ring. It was Trixie, the problem-solving fairy. "My best friend, Sparkle, is still hard at work. She is the tooth fairy. She collects all the baby teeth children lose just before they get their grown-up teeth. She never knows where she's going to find one, so she has to search every nook and cranny. It takes a very long time."

When Trixie had finished, a very important looking fairy
with a big stick stood before the Queen and banged the
ground three times. "Let the meeting begin," she
announced.

The first fairy to come before the Queen was Zoe, the
sewing fairy. She told everyone how she had made too
many fairy bags and didn't know what to do with them.

Then, while everyone puzzled over that problem, Ursula, the potion fairy, stood up.

"I've run out of sparkles," she explained. "Without sparkles, I can't make fairy dust, and without fairy dust there is no magic. We've just got to find something sparkly, pure and good to make more sparkles!"

Ursula had barely finished speaking, when a wretched looking creature flopped down in the centre of the fairy ring. It was a very tired and dirty-looking Sparkle. She'd had a hard night searching for baby teeth beneath dusty beds and grimy floorboards.

"I heard that," she panted. "And I've got just the thing." Sparkle reached into the bulging sack she was carrying and pulled out something that sparkled in the moonlight. "Baby teeth," she explained. "What could be more pure and good? And just look at that sparkle!"

Everyone, including Queen Isabella, agreed that it was a perfect solution.

"And I've had an idea for Zoe's fairy bags," announced Trixie. "We can give them to all the little children to put their fallen baby teeth in. Then they can put the bag under their pillow. That way, Sparkle won't have to spend so much time searching for lost teeth."

Sparkle nodded her head enthusiastically. "I think it would be nice if we left the children a reward for their teeth, too," she added. "After all, without them we wouldn't have any fairy dust."

"Hear, hear!" cried Queen Isabella enthusiastically. And so it was agreed.

The following day, before Sparkle flew off into the night, the fairies gathered together to write letters to all the little children in the world. As all the other fairies scribbled away, Sparkle told them what to write.

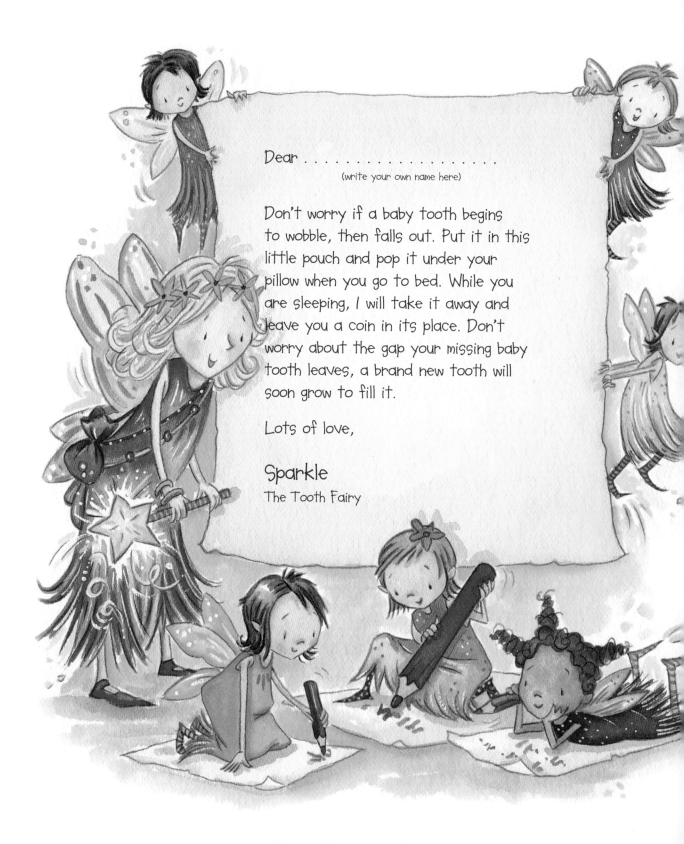

Dear

(write your own name here)

Don't worry if a baby tooth begins to wobble, then falls out. Put it in this little pouch and pop it under your pillow when you go to bed. While you are sleeping, I will take it away and leave you a coin in its place. Don't worry about the gap your missing baby tooth leaves, a brand new tooth will soon grow to fill it.

Lots of love,

Sparkle
The Tooth Fairy

When the letters were written, all the fairies helped
Sparkle deliver them, along with the fairy bags.

And from that day forth, Sparkle was never late for anything again because her job was much, much easier. All the little children put their baby teeth in their pouches and placed them under their pillows where Sparkle could find them. Never again did she have to scramble under beds or between floorboards. Sparkle was a very happy fairy.

And Sparkle wasn't the only one who was happy. Zoe was happy because all her lovely bags were being used. Ursula was happy because she had lots and lots of gorgeous sparkles for her fairy dust. Queen Isabella and the rest of the fairies were happy because they had lots of lovely fairy dust to do magical things with.

But, best of all, the little children were happy because they knew that if they looked after their baby teeth, and cleaned them regularly, they would get a reward whenever one fell out!

All About My Teeth

The chart below shows the position of all the baby teeth in your mouth. You can keep a record of your teeth, by colouring in each baby tooth when it falls out, and writing down the date on the opposite page.

My Tooth Chart